IMAGES
of America

MINNESOTA'S
ANGLING PAST

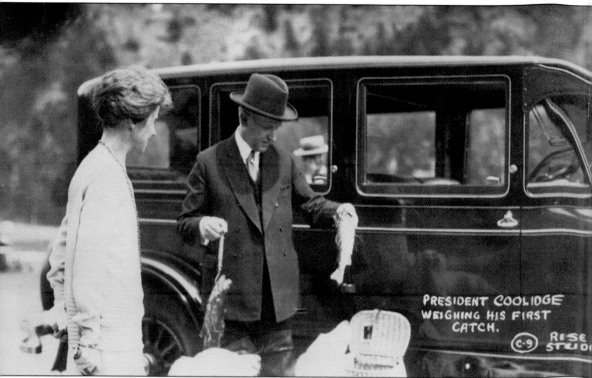

In the 1800s, the railroads brought anglers and those seeking cool summers and pristine lakes to Minnesota. The automobile rapidly increased the state's accessibility in the 1900s, when the state was touted as an ideal destination for out-of-doors vacationers. Pres. Calvin Coolidge visited Minnesota several times during his presidency, often finding time to go fishing; this c. 1925 photograph shows Coolidge displaying his catch. (Courtesy of Minnesota Historical Society.)

ON THE COVER: The caption written on the front of this photograph describes "a two hours catch" of what appears to be mostly walleye for this group, which was staying at Goodwill's Summer Home on Lake Vermilion. The large lake, at nearly 40,000 acres, remains a popular destination for walleye fishers. (Courtesy of Northwest Minnesota Historical Center.)

IMAGES
of America

MINNESOTA'S ANGLING PAST

Thomas A. Uehling

ARCADIA
PUBLISHING

Published by Arcadia Publishing
Charleston, South Carolina

Printed in the United States of America

Library of Congress Control Number: 2013937112

For all general information, please contact Arcadia Publishing:
Telephone 843-853-2070
Fax 843-853-0044
E-mail sales@arcadiapublishing.com
For customer service and orders:
Toll-Free 1-888-313-2665

Visit us on the Internet at www.arcadiapublishing.com

Lord, suffer me to catch a fish so large that even I in talking of it afterward shall have no need to lie.

Motto over President Hoover's fishing lodge

CONTENTS

Acknowledgments 6

Introduction 7

1. Southern Region 9

2. Metro Region 23

3. Central Region 35

4. Northwest Region 69

5. Northeast Region 101

State Record Fish 126

ACKNOWLEDGMENTS

As I traveled across Minnesota searching for interesting photographs, I met many of the people who are committed to carefully archiving and recording our history. Without their years of meticulous work, my task would have been impossible. The organizations listed below contributed images and information for this book, and I am grateful for their assistance.

Becker County Historical Society, Detroit Lakes
Beltrami County Historical Society, Bemidji
Big Stone County Historical Society, Ortonville
Cass County Historical Society, Walker
Clearwater County Historical Society, Bagley
Dorothy Molter Museum, Ely
Douglas County Historical Society, Alexandria
Ely-Winton History Museum, Ely
The History Museum of East Otter Tail County, Perham
Minnesota Department of Natural Resources, St. Paul
Minnesota Discovery Center, Chisholm
Minnesota Historical Society, St. Paul
Minnesota Fishing Museum, Little Falls
Minnesota Museum of Mining, Chisholm
Nobles County Historical Society, Worthington
Northeast Minnesota Historical Center, University of Minnesota Duluth
Northwest Minnesota Historical Center, Minnesota State University Moorhead
North Star Museum of Boy Scouting and Girl Scouting, St. Paul
Pope County Historical Society, Glenwood
Roseau County Historical Society, Roseau
Stearns History Museum, St. Cloud
St. Paul Pioneer Press

Unless otherwise noted, all images are courtesy of the author's private collection.

INTRODUCTION

Minnesota has a diverse landscape ranging from the rocky, boreal forests of the north to the fertile prairie lands in the south. The fishing opportunities throughout the state are equally diverse. Anglers can pursue lake trout in deep cold-water lakes, walleye in famed "fish factories" such as Mille Lacs, and a host of other fish species throughout the state's lakes and streams.

With all its diversity, the "land of 10,000 lakes" has been attracting tourists even before it became a state in 1858. Arriving by steamboat and railroad, early visitors were interested in the state's fishing and hunting opportunities as well as its aesthetic qualities. Resort areas developed in the Minneapolis region and along the north shore of Lake Superior. Reaching the lakes of the northernmost part of the state remained difficult until the early 1900s, when extensive mining and logging activities began to make the region more accessible. With the rise of automobile tourism, an improving road system, and a concerted effort to promote the state's resources, tourism quickly became a major industry.

Over the past century, innovative boatbuilders, fishing tackle designers, resort owners, guides, and many others have contributed to Minnesota's angling reputation. Today, the state remains an excellent fishing destination that supports thousands of businesses and thousands of jobs. Thanks to tightened size restrictions and harvest limits, there are still many trophy fish lurking in the state's waters.

Many fishing traditions conceived over the years are still celebrated today. For example, the Governor's Fishing Opener kicks off the walleye season each May and helps to promote the state's tourism and fishing industries. The opening of fishing season in general is a bit of a holiday in Minnesota. The roads are filled with vehicles towing boats, many of which will be launched at midnight just as the walleye season begins.

As the photographs in this book show, many aspects of the angling experience have changed, and some are gone forever. The mom-and-pop resort industry peaked in the 1970s and has been declining as lakeshore land values rise and selling the land to developers becomes more lucrative. The quaint wooden rowboats have been replaced by high-powered fiberglass fishing boats. The simple cane pole and the secret fishing spot have been replaced by lightweight graphite and electronic fish-finders with GPS technology. Some of the lakes mentioned in these pages no longer exist, having been drained for flood control projects or to open up more farmland. Giant lake sturgeon are no longer found where they once thrived in some of the state's waters, although there are some successful comeback stories.

Minnesota's angling past is spread across the state in the form of photographs, newspaper clippings, fish mounts, and stories. Sadly, some of that history has been lost. In one case, a mount of Minnesota's record muskellunge (caught in 1957) was destroyed in 1979 when the bar it was displayed in burned down. Some old photographs and newspaper records have met a similar fate. In an effort to preserve some of that history, this book is a pictorial collection of some of the people, places, and events that shaped Minnesota's distinction as a fishing paradise. The people in these photographs no doubt had the same passion for fishing that today's anglers feel—that thrill that comes from watching a bobber go down and the ensuing battle with a big fish.

This book focuses on sportfishing rather than commercial fishing, with the thought that the latter was such a major part of the state's early history that it deserves a book of its own. This book is organized according to regions of the state, which all have different geography and led to many varied angling experiences; it offers readers a chance to enjoy the moments that anglers before us deemed worthy enough to capture.

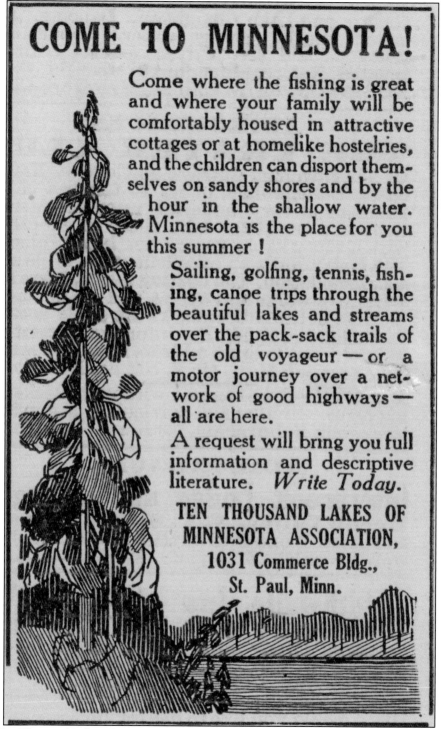

COME TO MINNESOTA!

Come where the fishing is great and where your family will be comfortably housed in attractive cottages or at homelike hostelries, and the children can disport themselves on sandy shores and by the hour in the shallow water. Minnesota is the place for you this summer !

Sailing, golfing, tennis, fishing, canoe trips through the beautiful lakes and streams over the pack-sack trails of the old voyageur — or a motor journey over a network of good highways — all are here.

A request will bring you full information and descriptive literature. *Write Today.*

TEN THOUSAND LAKES OF MINNESOTA ASSOCIATION, 1031 Commerce Bldg., St. Paul, Minn.

The Ten Thousand Lakes of Minnesota Association was the main promoter of tourism in the state from 1917 until the 1930s. This early print advertisement promises great fishing, sandy shores, and beautiful lakes and streams.

One

SOUTHERN REGION

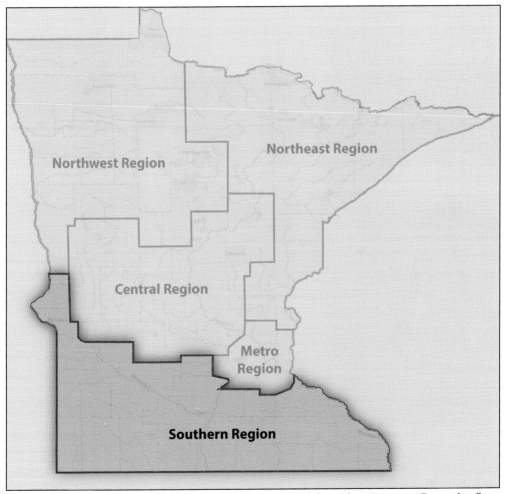

The southern region features fertile, mostly shallow prairie lakes. The Minnesota River also flows here, and the Mississippi River exits the southeast corner of the state. In the late 1800s and into the 1900s, many small lakes and wetlands were drained in the southern region as demand increased for cropland. However, the lakes that remained have long provided excellent fishing opportunities.

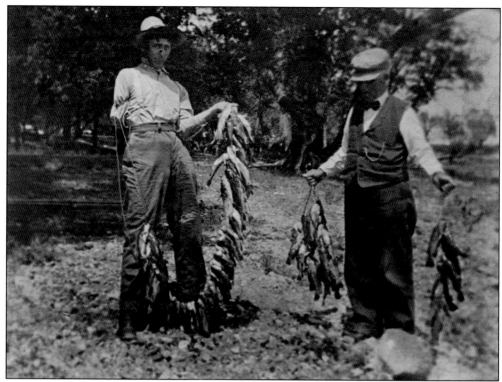

Summit Lake, where these fish were caught in the early 1900s, no longer exists. It was one of many lakes drained to provide additional farmland. The fish appear to be bullheads, which are common in much of the state. (Courtesy of Nobles County Historical Society.)

In this 1916 image, two women fish from the shore of Okabena Lake in Worthington. Based on its shape, the fish was probably a walleye. Early maps show that an East Okabena Lake once existed, but it was drained in 1899 to protect a railroad bed, according to the *Worthington Advance* newspaper. (Courtesy of Nobles County Historical Society.)

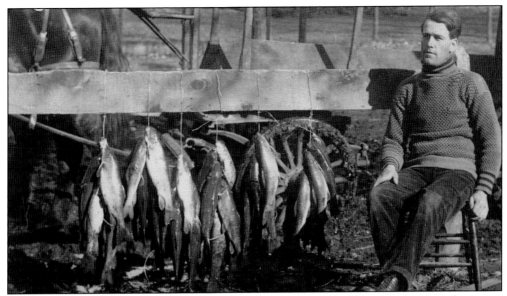

The caption on this photograph states that these 58 fish—probably carp—were caught in one hour in Okabena Lake around 1910. (Courtesy of Nobles County Historical Society.)

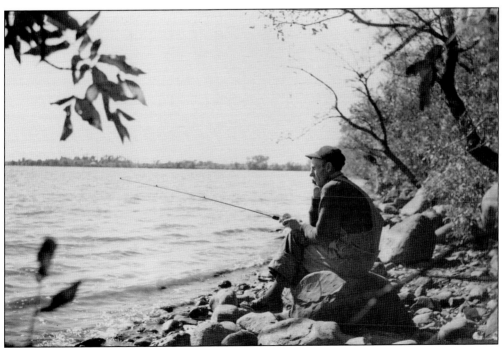

Fall can be a great time for shore fishing as the water cools and fish move to shallower areas. This man seems to be enjoying an October day on Okabena Lake in 1941. (Courtesy of Nobles County Historical Society.)

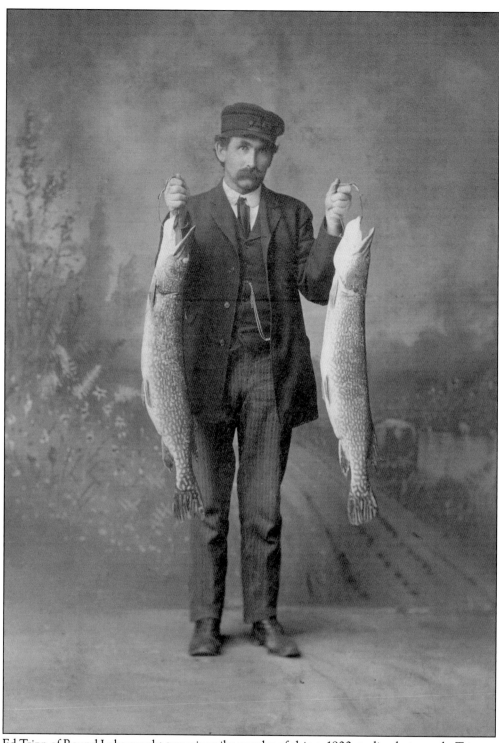

Ed Tripp of Round Lake caught two nice pike worthy of this c. 1900 studio photograph. Tripp, a resident of Round Lake before it was incorporated as a town, eventually became the postmaster there. (Courtesy of Nobles County Historical Society.)

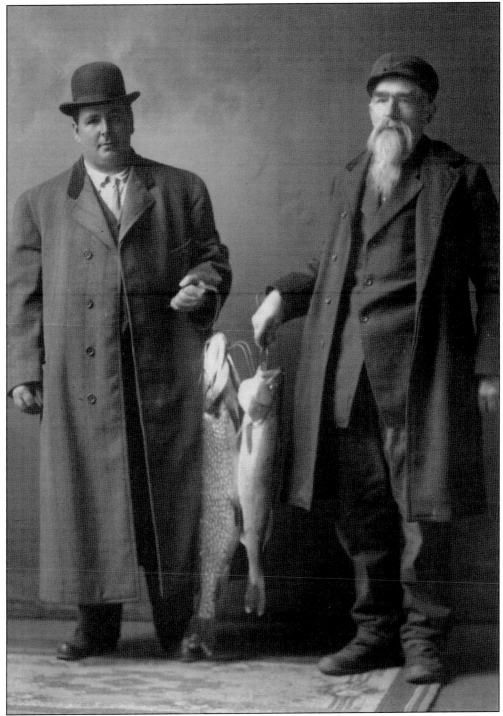

The men who caught the large northern pike (left) and walleye in this 1913 photograph are from the Mankato area, where a group of fertile and mostly shallow lakes continues to provide excellent largemouth bass, northern pike, and walleye fishing. (Courtesy of Blue Earth County Historical Society.)

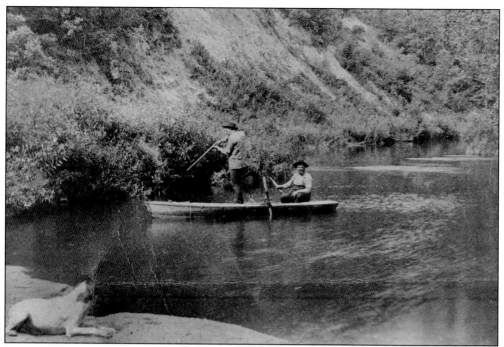

People have attempted to use many techniques for harvesting fish over the years. These men appear to be shooting fish from a boat on the Cottonwood River, near New Ulm, around 1890. Under current law, it is illegal to use explosives, firearms, chemicals, or electricity to take fish. (Courtesy of Minnesota Historical Society.)

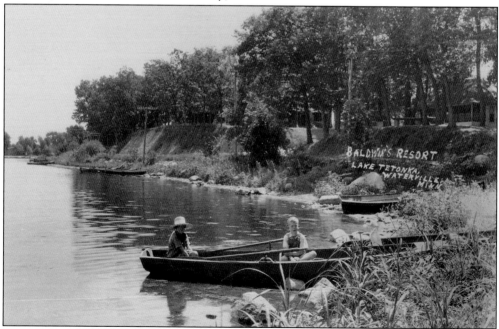

While most people associate the northern half of Minnesota with resort country, many resorts sprang up in the southern half as well. Baldwin's Resort was on Lake Tetonka. This postcard, mailed in 1947, is one of the few pieces of evidence that the resort was ever there.

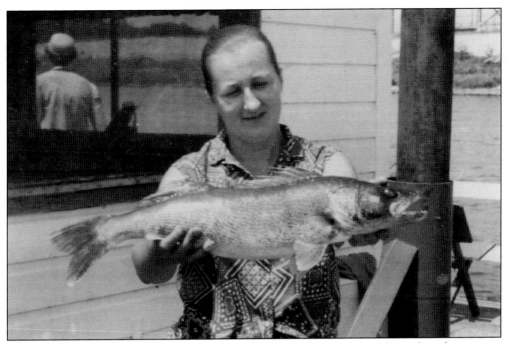

The sauger is a relative of the more common walleye. The Mississippi River has the greatest potential for large saugers of any waterway in Minnesota. This sauger, caught by Wylis Larson in July 1964 below lock and dam no. 4 on the Mississippi, weighed 6 pounds and 2.5 ounces, just shy of the current state record. (Courtesy of Minnesota Department of Natural Resources.)

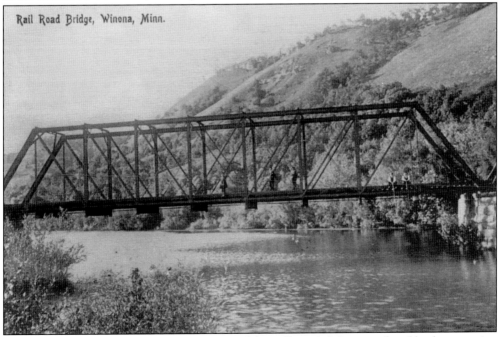

This postcard, mailed in 1908, shows two men fishing (far right) from a railroad bridge spanning part of the Mississippi River in Winona. The town, known for its scenic bluffs along the river, grew rapidly in its early years due to its rail and steamboat transportation.

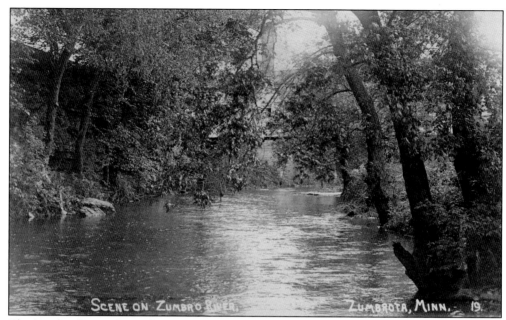

The Zumbro River, shown here on a 1928 postcard, is located in the southeastern part of the state, with one branch passing through Rochester. The Zumbro is known for its good fishing for catfish, smallmouth bass, bullheads, and suckers.

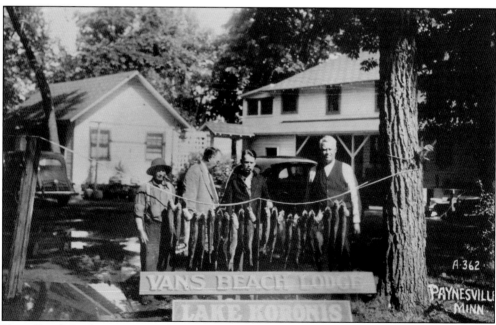

Vans Beach Lodge was one of several resorts on Lake Koronis, near Paynesville, in the 1940s. Rates were $21–$30 per week and included a boat and gas. (Courtesy of Minnesota Historical Society.)

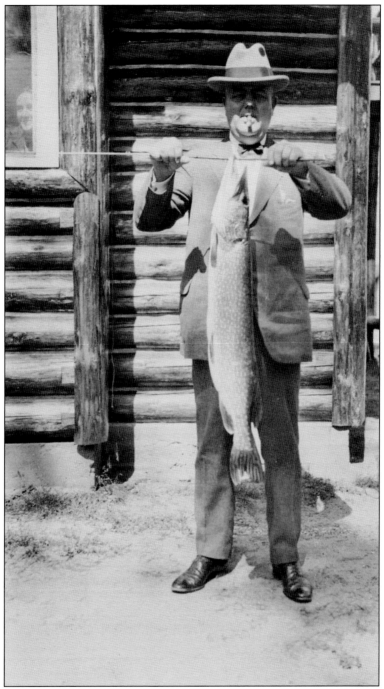

Theodore Christianson served as the 21st governor of Minnesota from January 6, 1925, until January 6, 1931. He is pictured here displaying a dandy northern pike. He was born on a farm in Lac qui Parle County. The county contains Lac qui Parle Lake—a French translation of the name given to the lake by the Dakota Indians, who called it the "lake that speaks." The lake is a stopover for thousands of migratory waterfowl each spring and fall. (Courtesy of Minnesota Historical Society.)

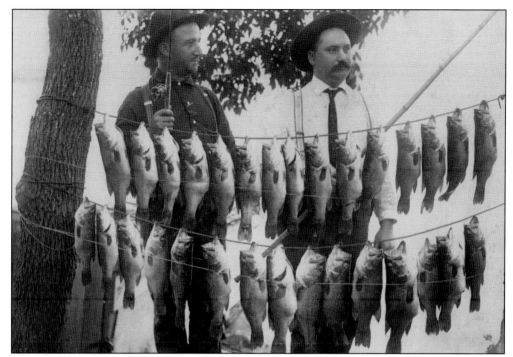

The caption on this c. 1900 photograph reads: "30 bass, 30 minutes." The bass were likely caught in Big Stone Lake, which runs along the Minnesota–South Dakota border and is the starting point of the Minnesota River. (Courtesy of Big Stone County Historical Society.)

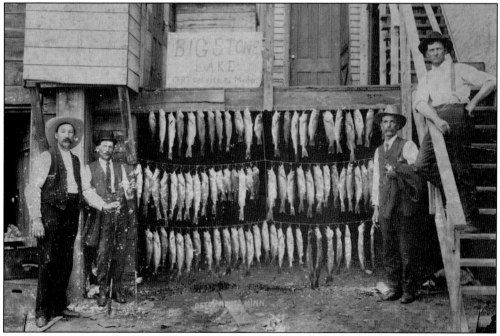

These four men appear to have had an excellent day of fishing for walleye, bass, and northern pike in Big Stone Lake around 1900. All three species remain highly sought after in the lake today. (Courtesy of Big Stone County Historical Society.)

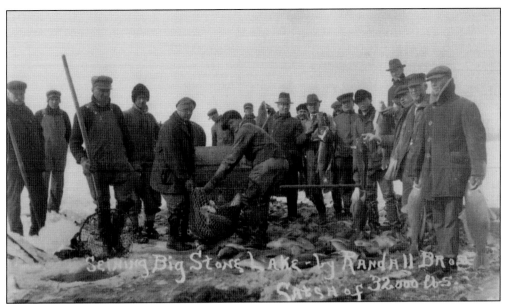

This 1916 photograph shows that a large number of carp were seined in Big Stone Lake. The caption indicates that 32,000 pounds were caught that day. (Courtesy of Big Stone County Historical Society.)

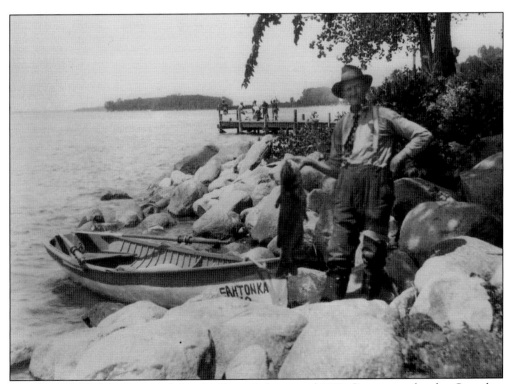

Gus Orton landed this large catfish in Big Stone Lake around 1900. Orton was related to Cornelius Orton, the founder of Ortonville. The boat in this photograph was likely rented from Eahtonka Resort. (Courtesy of Big Stone County Historical Society.)

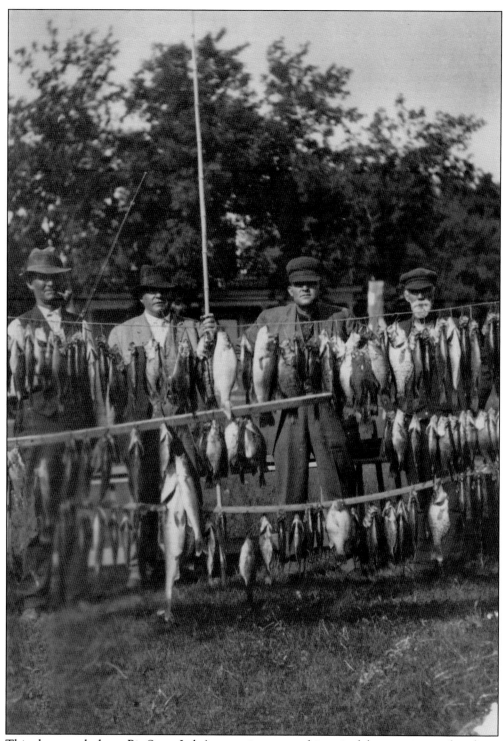

This photograph shows Big Stone Lake's attraction as a multispecies lake containing white bass, largemouth bass, crappie, and walleye. Although the lake is over 11,000 acres in size, its maximum depth is only 16 feet. (Courtesy of Big Stone County Historical Society.)

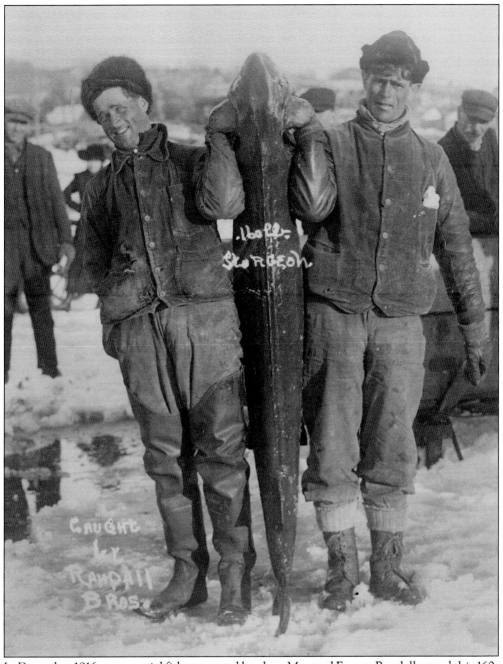

In December 1916, commercial fishermen and brothers Max and Everett Randall netted this 160-pound sturgeon in Big Stone Lake. (Courtesy of Big Stone County Historical Society.)

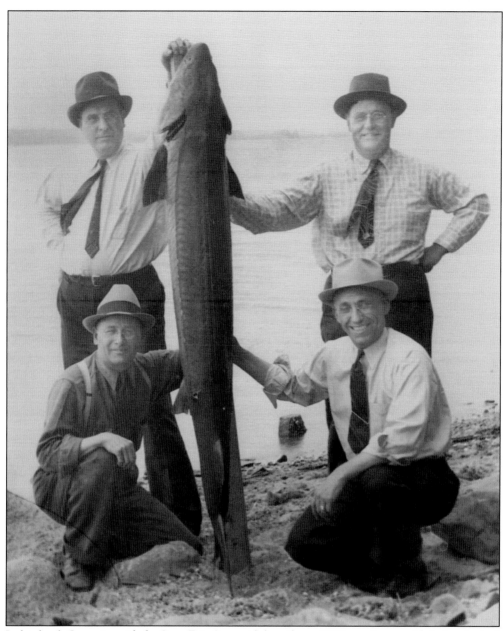

In his book *Canoeing with the Cree*, Eric Sevareid describes a 1930 encounter with "what looked like a big black log, slowly sinking from sight" on Big Stone Lake. He then realized that it was a sturgeon. The 110-pound sturgeon in this photograph was found dead or was speared near Big Stone Lake in the 1940s. Today, lake sturgeon no longer swim in Big Stone Lake. The construction of dams on the Minnesota River and changes in water quality may have contributed to their demise. (Courtesy of Big Stone County Historical Society.)

Two

METRO REGION

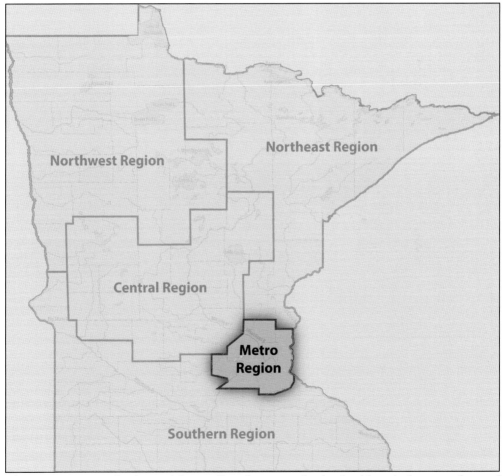

The metro region is the focus of the smallest chapter in this book, although there are plenty of good fishing lakes in the Minneapolis–St. Paul area. The best known of these is Lake Minnetonka, which spans about 14,500 acres and has long been a popular destination.

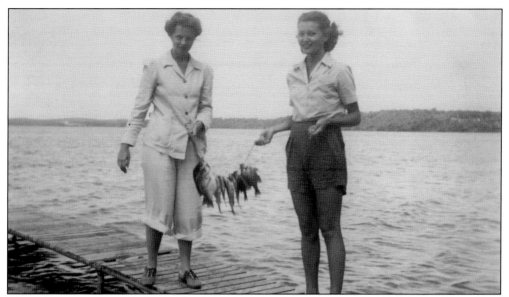

The seven-county metropolitan area includes the cities of Minneapolis and St. Paul and has hundreds of lakes. Residents of the Twin Cities need not travel far to find good fishing. This 1944 photograph shows two anglers with a nice catch of bluegills near Crystal.

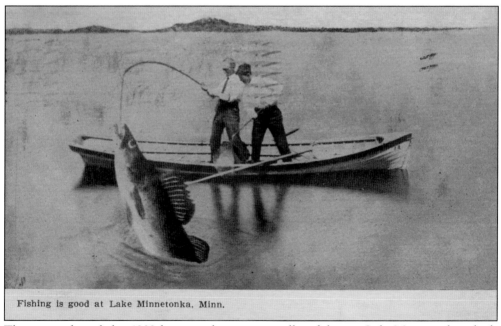

Fishing is good at Lake Minnetonka, Minn.

This postcard, mailed in 1909, humorously promotes walleye fishing at Lake Minnetonka, which means "Big Waters" in the Dakota language. The lake is located only 20 miles west of Minneapolis and remains a popular destination for angling and boating.

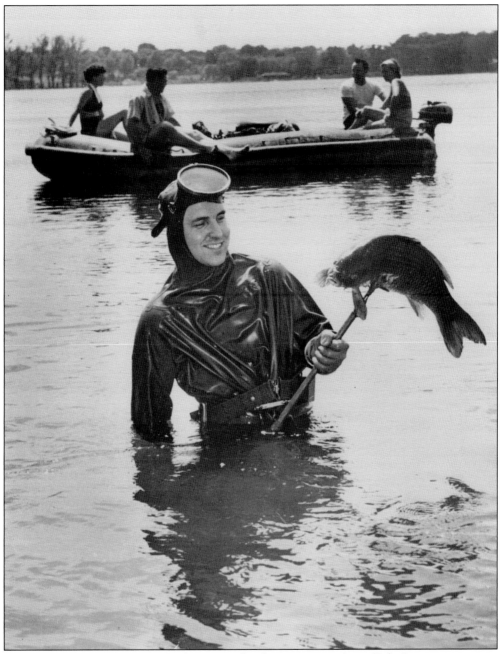

Carp, which were stocked in the late 1800s by the Minnesota State Fish Commission, are a nonnative fish species. The carp multiplied rapidly in parts of Minnesota and are now considered by many to be a nuisance. This photograph shows Roger Nellesen's success during a carp-spearing contest held in Excelsior in 1954, possibly as a means to control the carp population.

Hundreds of fishing-related companies were born in Minnesota in the 1900s as fishing and tourism became major industries. The Minnesota Fishing Tackle Company in Minneapolis touted a collapsible bamboo fishing pole in this 1951 advertisement.

The Paul Bunyan Bait Company, also based in Minneapolis, produced many popular lures, including the "66" spinner shown in this 1952 advertisement.

This photograph was likely used in a tourism brochure, as indicated by the crop marks on the image and an accompanying caption that states, "If it's black bass you're after, here is a mark to shoot at: a five-pounder, of which there are many in most of Minnesota's lakes." Black bass is another name for largemouth bass.

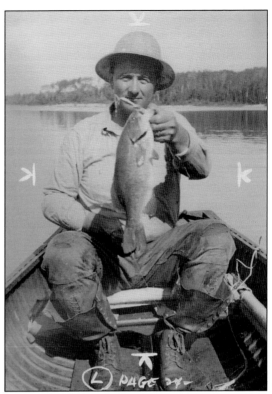

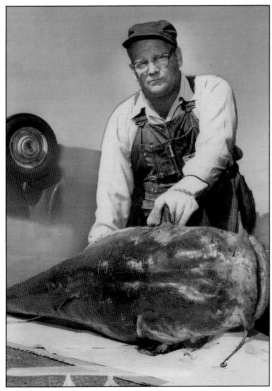

Al Stoll beached this 60-pound flathead catfish in the St. Croix River near Stillwater after a 90-minute battle. The September 1960 catch stood as the Minnesota record for about 10 years. A newspaper account in the *St. Paul Pioneer Press* noted that Stoll was actually fishing for sturgeon at the time. (Courtesy of *St. Paul Pioneer Press*.)

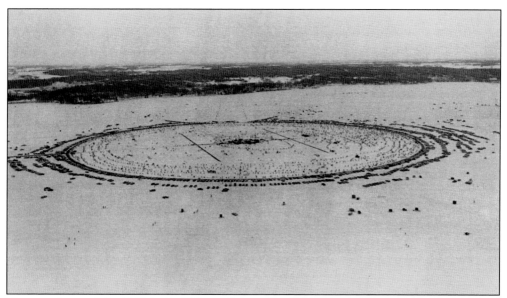

This aerial view of the 1965 St. Paul Winter Carnival on White Bear Lake shows the circle created by cars parked on the perimeter of the event. A giant "H" was formed inside the circle to honor Vice Pres. Hubert Humphrey, the grand marshal.

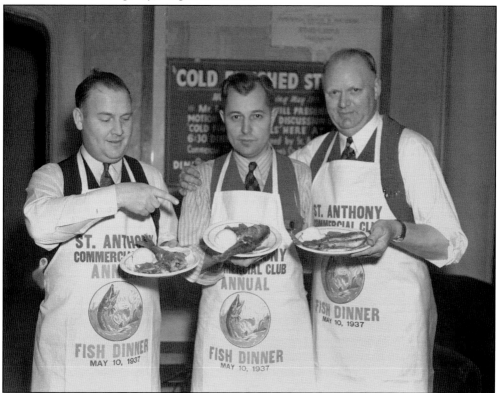

Fish dinners have long been a tradition in Minnesota. Here, three members of the St. Anthony Commercial Club display the meal at their annual fish dinner on May 10, 1937. (Courtesy of Minnesota Historical Society.)

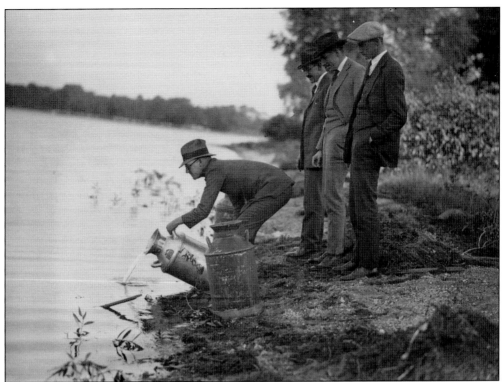

In an effort to preserve the state's reputation as a fishing paradise, the Minnesota Fish Commission began stocking programs in 1874. Other groups assisted in these efforts, including the Izaak Walton League, several members of which are seen here in 1925. While the result was the spread of some undesirable (depending on who one asks) fish such as the carp, the state also expanded the populations of desirable fish such as stream and lake trout, walleye, and bass. (Courtesy of Minnesota Historical Society.)

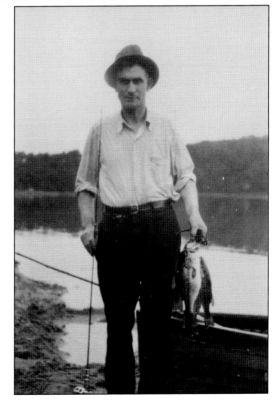

John Runk was a well-known Minnesota photographer who used motion film to capture many images of life in the early 1900s. Runk is pictured here in 1924 with a nice catch of largemouth bass, presumably from the Stillwater area where he did much of his work. (Courtesy of Minnesota Historical Society.)

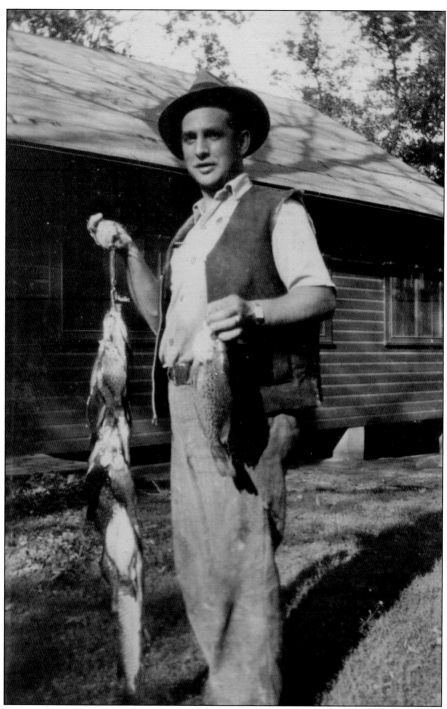

The caption on this 1933 photograph of a full stringer of crappies and a northern pike says: "Sid Holmes gets 'em." The crappie in Holmes's left hand appears to be in the 12-inch class. The photograph was taken at the Boy Scout summer camp on Square Lake in Washington County. The camp was closed in 1937 after sustaining severe storm damage. (Courtesy of North Star Museum of Boy Scouting and Girl Scouting.)

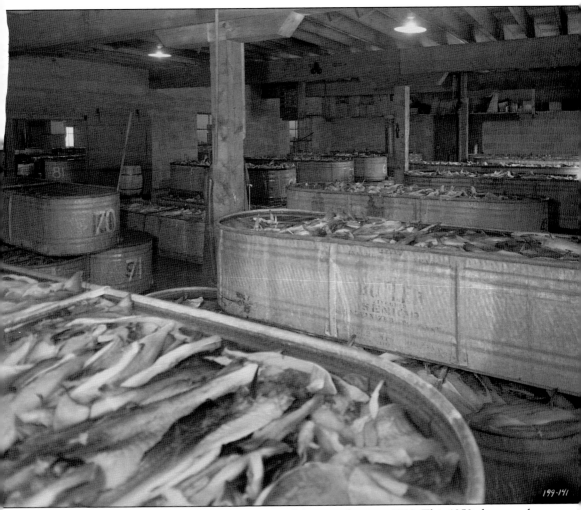

199-141

The Olsen Fish Company has been operating in Minneapolis since 1910. This 1950 photograph shows tanks of lutefisk, which translates to "lye fish." When the preparation process is complete, lutefisk has a gelatinous texture and a strong odor. It is popular in the Norwegian, Swedish, and Finnish communities in Minnesota, and lutefisk feeds are common in the cold-weather months. (Courtesy of Minnesota Historical Society.)

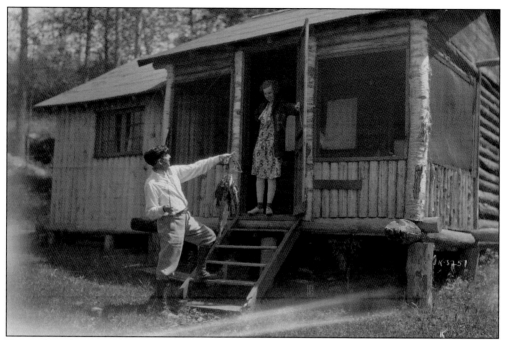

Kenneth Melvin Wright took this amusing c. 1930 photograph of a man presenting his catch of the day. Wright was associated with studios in St. Paul and captured many images of Minnesota's outdoor activities in the 1930s and 1940s. (Courtesy of Minnesota Historical Society.)

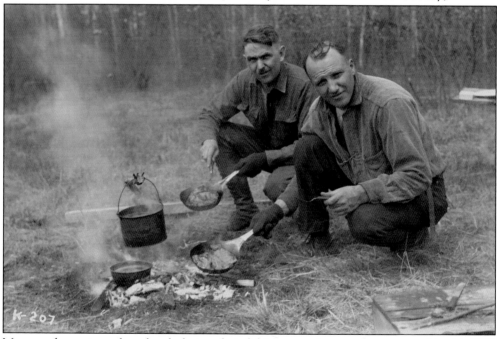

Many anglers enjoy a shore lunch during their fishing excursions, as demonstrated in this 1935 photograph. Typically, fish are filleted, breaded, and dropped into hot oil. For many anglers, fried potatoes and beans accompany the meal. Kenneth Melvin Wright also took this photograph, although the location is unknown. (Courtesy of Minnesota Historical Society.)

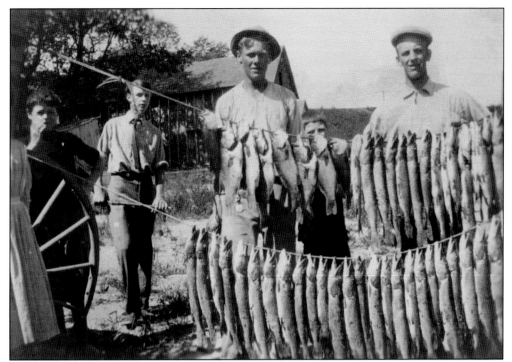

This c. 1913 photograph shows a nice catch of northern pike and bass from Snail Lake in Ramsey County. While it is only 160 acres in size, the lake continues to produce decent numbers of northern pike. (Courtesy of Minnesota Historical Society.)

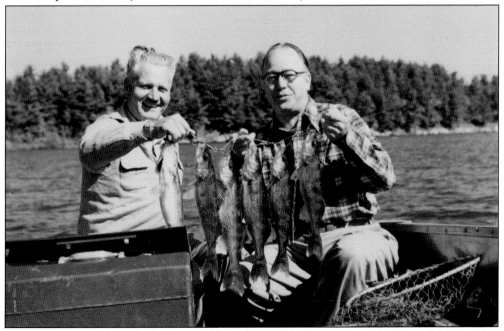

Gov. Luther Youngdahl (left) is pictured here during a fishing trip in 1950. Youngdahl served as Minnesota's 27th governor from January 8, 1947, to September 27, 1951. (Courtesy of Minnesota Historical Society.)

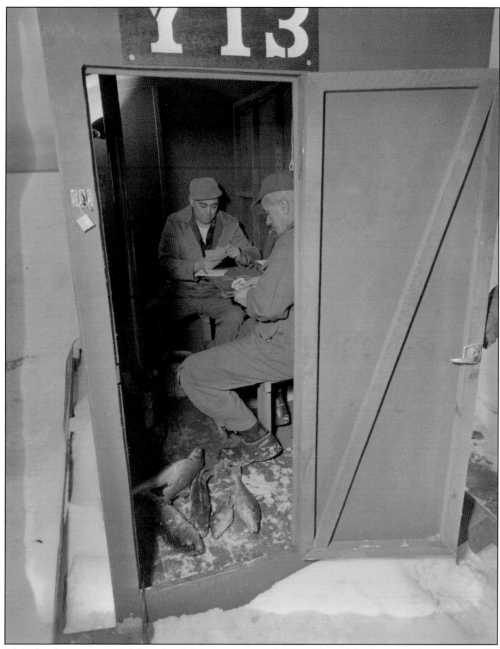

This shack represented deluxe ice-fishing accommodations when this photograph was taken for the *Minneapolis Star Tribune* in 1953. While catching walleye and perch is part of the experience, winter fishing also provides some time for socializing and playing cards. (Courtesy of Minnesota Historical Society.)

Three

CENTRAL REGION

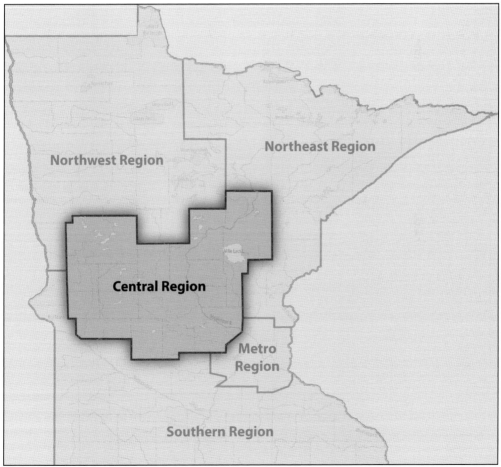

The heart of Minnesota features clear lakes with sandy beaches surrounded by wooded hills. A short trip northwest of Minneapolis–St. Paul, the region is a popular destination for family vacations and weekend getaways.

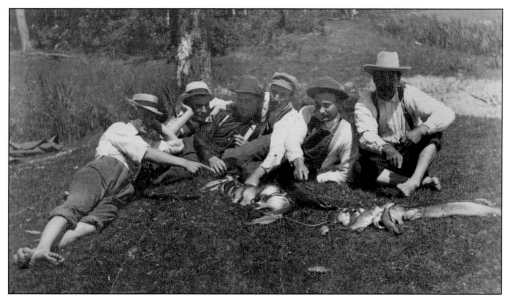

These men caught a stringer of crappies, bass, and northern pike during an outing on Pelican Lake, near St. Anna, in 1911. Today, this small, 300-acre lake still has populations of those species and has also been stocked with walleye since 1945. (Courtesy of Stearns History Museum.)

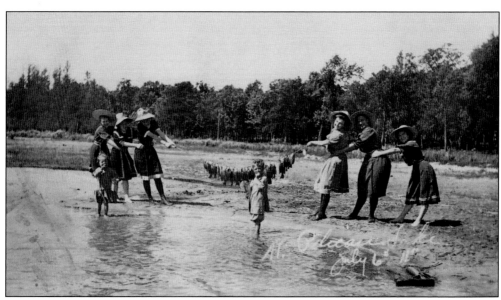

This photograph was part of the same collection as the image at the top of the page. These women, presumably on the same trip as the men pictured above, were having fun as they displayed a nice catch of bluegills and crappies (often referred to as pan fish) from Pelican Lake. (Courtesy of Stearns History Museum.)

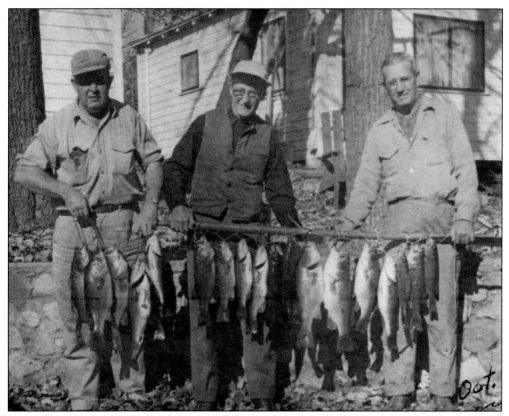

Horseshoe Lake, in Richmond, is part of the Sauk River Chain of Lakes, which was formed after the construction of a dam on the Sauk River in Cold Spring. The lake has a variety of fish, including bass, as shown in this 1958 photograph taken during a fall fishing trip out of Lake View Resort on Horseshoe Lake. (Courtesy of Stearns History Museum.)

These men also did well in their pursuit of bass on Horseshoe Lake during a 1954 trip. They had a few northern pike mixed in as well. (Courtesy of Stearns History Museum.)

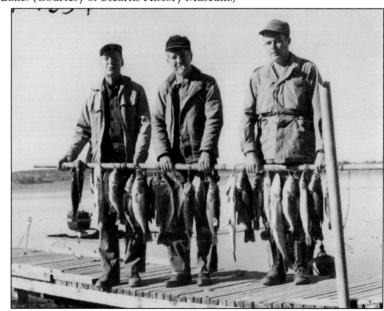

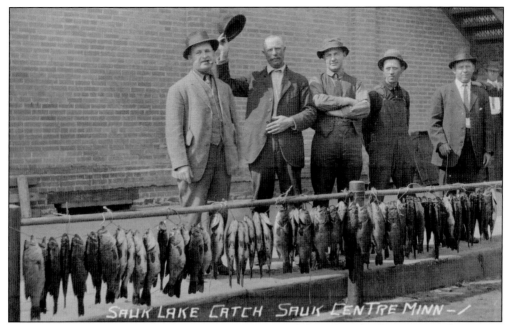

Sauk Lake, near the town of Sauk Centre, gave up several dozen bass for this group in about 1930. The lake still holds a moderate population of largemouth bass, some of which are over 20 inches long. (Courtesy of Minnesota Historical Society.)

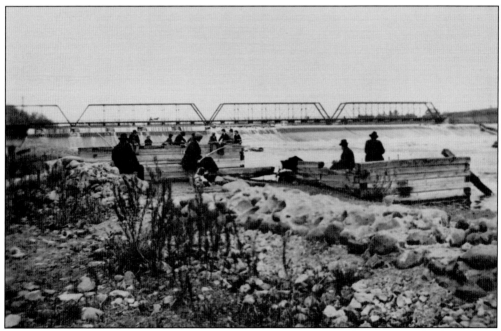

There are many areas throughout the state where one can fish from shore, especially along rivers. These anglers gathered in 1904 to try to catch northern pike along the Mississippi River below the dam in St. Cloud. (Courtesy of Stearns History Museum.)

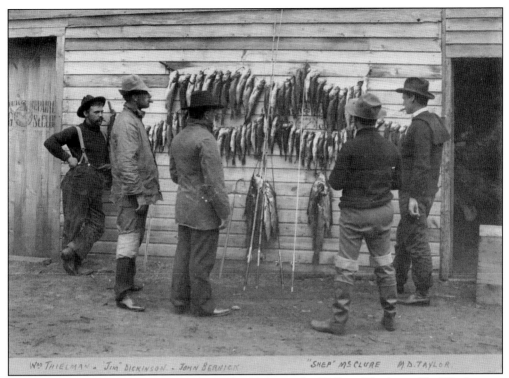

Pictured in this early 1900s photograph are, from left to right, William Thielman, "Jim" Dickinson, John Bernick, "Shep" McClure, and M.D. Taylor as they size up a catch of walleyes and some northern pike. The fish were caught on a lake in the St. Cloud area. (Courtesy of Stearns History Museum.)

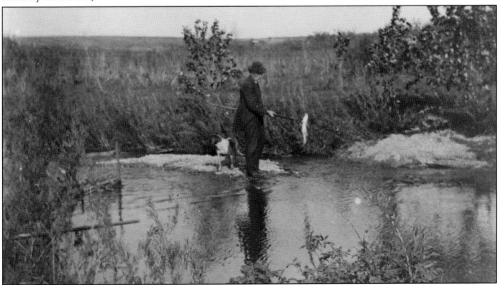

This man in this 1905 photograph was likely spearing white suckers near Sauk Centre. The white sucker is among the most common fish in the state. The sucker tastes good when it is smoked or baked, but it is also used as bait for walleye, northern pike, and muskellunge. (Courtesy of Stearns History Museum.)

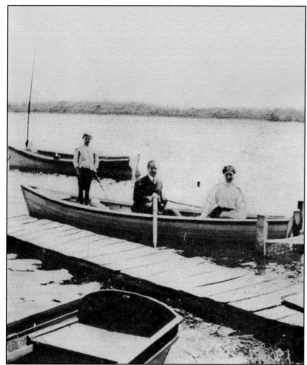

This early photograph shows a group preparing to row out onto Lake Charlotte, in Wright County. Spanning about 230 acres, Charlotte is one of dozens of lakes easily accessible from the Minneapolis–St Paul area. In past years, the Minnesota Department of Natural Resources stocked walleye in the lake, but it discontinued the practice in 1990 due to poor results.

Fish-stocking programs go back to at least the late 1800s. The c. 1910 photograph below shows the St. John's Abbey fish hatchery in Collegeville. (Courtesy of Stearns History Museum.)

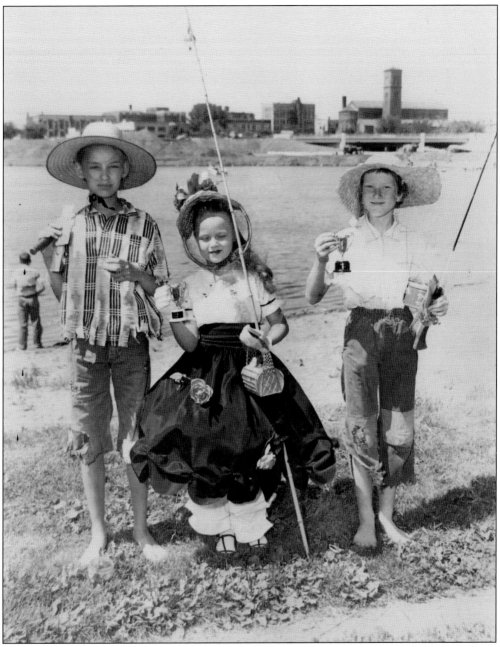

With so many lakes in Minnesota, it is not hard to find a fishing contest being held somewhere. These young anglers were the winners of a 1960s citywide fishing contest on Lake George in St. Cloud. Previously a shallow swamp, Lake George was dredged in the late 1920s and is now 32 feet deep in places. (Courtesy of Stearns History Museum.)

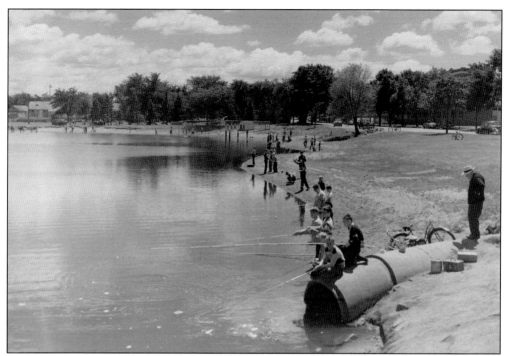

Anywhere there is a lake or stream within a town in Minnesota, it is easy to find anglers along the shoreline, especially in the spring and fall, when the fish are in the shallows. This photograph of Lake George in St. Cloud was probably taken during the citywide fishing contest in 1960. (Courtesy of Stearns History Museum.)

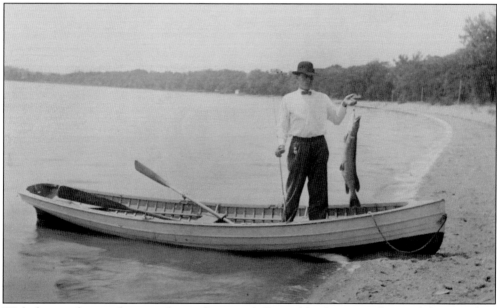

With their mad runs, a large northern pike or muskellunge like the one in this 1915 photograph—from Grand Lake, south of Rockville—can pull a small, unanchored boat or canoe for a short distance. The key for the angler is to keep the toothy fish from snapping the line or burying itself in thick weeds. (Courtesy of Stearns History Museum.)

42

These men had a good day fishing near Cold Spring in 1951. The northern pike being held by itself on the far left was probably in the 10-pound range. (Courtesy of Stearns History Museum.)

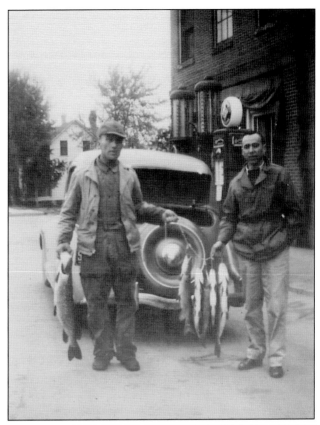

Granite quarries like the one below have operated in the St. Cloud area since the late 1800s. Some abandoned quarries—filled with clear, cool water—have been stocked with rainbow trout since the 1930s, drawing anglers like the ones pictured here around 1940. Some of the quarries continue to be stocked today. More recently, abandoned open-pit iron mines in northern Minnesota have also been stocked with trout. (Courtesy of Stearns History Museum.)

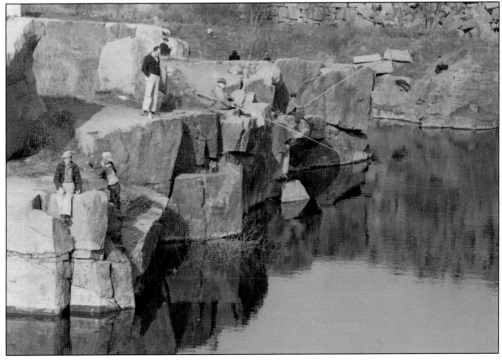

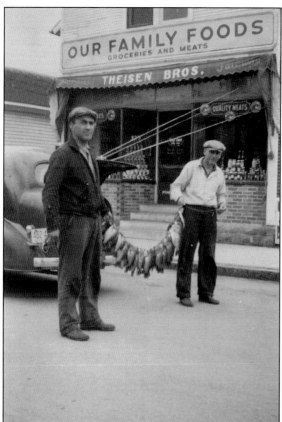

One can only guess how many pounds of crappies these men caught in 1941. They stopped long enough to take this photograph in front of the Theisen Brothers store in Cold Spring. (Courtesy of Stearns History Museum.)

Fishing through the ice for northern pike is popular in Minnesota. The pike are often caught in depths of less than five feet, especially early in the season. These pike fishermen from Elrosa apparently had a successful day in 1947. (Courtesy of Stearns History Museum.)

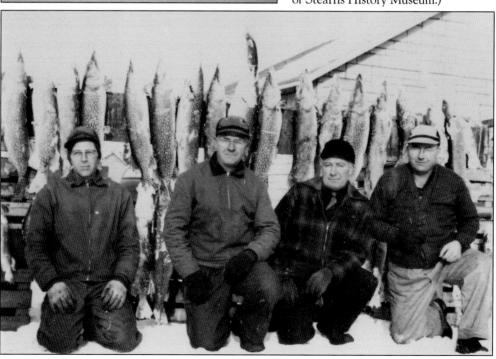

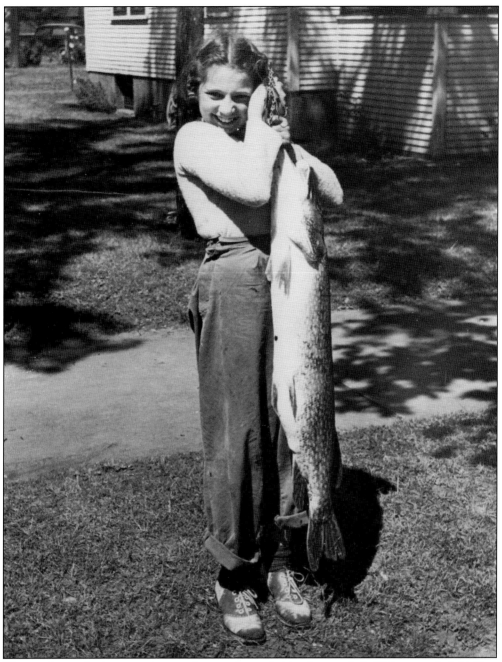

The northern pike is a voracious predator and eagerly bites lures or bait. This young lady holds a good-sized pike caught in the central part of the state around 1950. While the average size of northern pike seems to be lower today due to more anglers on the lakes and more fish harvested, some anglers still catch trophy fish that weigh over 20 pounds. (Courtesy of Stearns History Museum.)

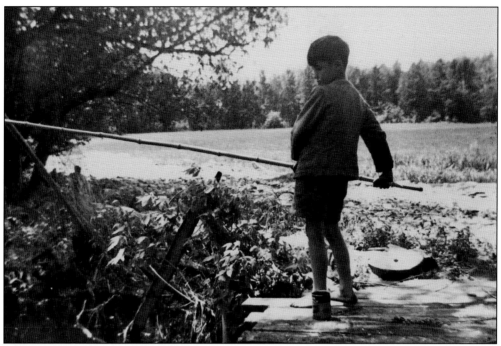

Many lifelong residents of Minnesota have memories of fishing in a stream or a pond as a child. In this 1937 image above, a youngster uses a simple cane pole to fish a stream near Rockville. Judging by the can of corn near his feet, it is possible that he was fishing for rainbow trout. (Courtesy of Stearns History Museum.)

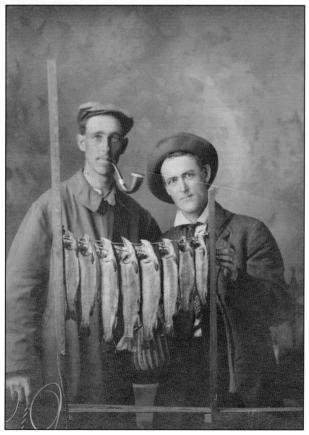

These fellows had a nice outing near St. Cloud in August 1911 and decided to preserve their catch of rainbow trout in a studio photograph. The state has many trout streams, especially in the northeast and southeast. (Courtesy of Stearns History Museum.)

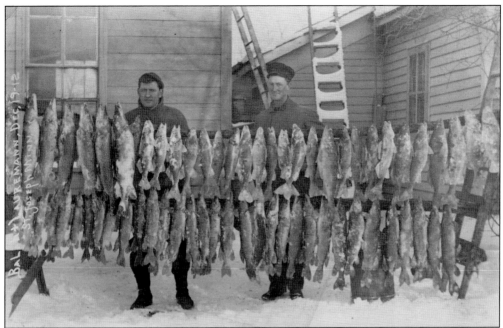

Above, Lawrence Balch and Johnny Lauerman display a large catch of walleye and northern pike on December 19, 1912, near St. Joseph. In the early 1900s, anglers could keep more fish than they can today. A 1916 article in the *Minneapolis Morning Tribune* stated that, per day, 15 bass or walleye could be kept, 25 crappies or trout of any variety could be kept, and there was no limit on other varieties. (Courtesy of Stearns History Museum.)

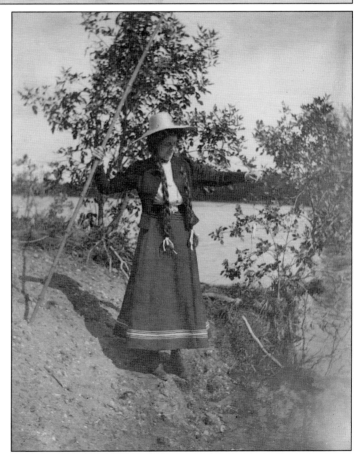

This woman was possibly fishing for largemouth bass from the shore of Briggs Lake in 1905. There appears to be a frog—excellent bass bait—at the end of her line. (Courtesy of Stearns History Museum.)

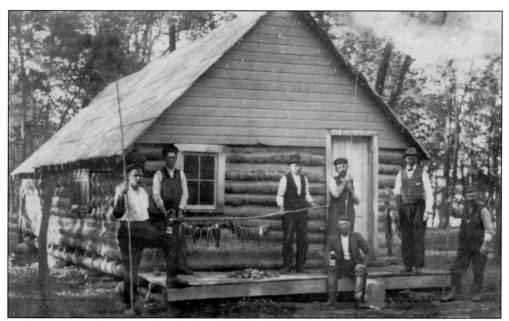

Heading to the cabin for a fishing trip has long been a Minnesota tradition. These men appear to have caught a nice mix of fish during a 1910 trip to Nic Ganzer's cabin on the Sauk River, near Cold Spring. (Courtesy of Stearns History Museum.)

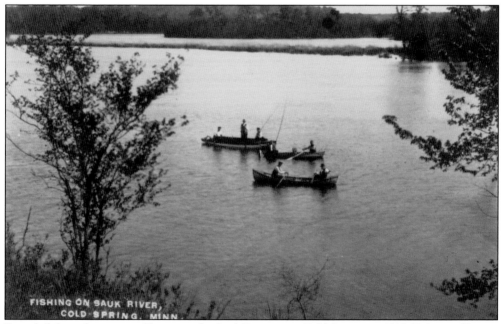

Friends fish in this group of boats on the Sauk River near Cold Spring in 1910. Fishing offers an opportunity to socialize—often by choice, as seen here, but sometimes because a hot spot is only several yards wide. (Courtesy of Stearns History Museum.)

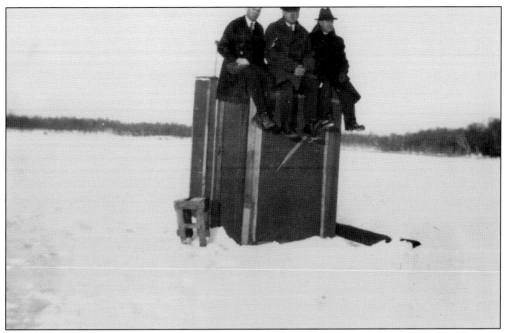

These men, pictured on January 11, 1920, were probably spearing northern pike through the ice on Cedar Lake, near St. Rosa. They decided to take a break to capture a photograph of them sitting on top of their spearing house. (Courtesy of Stearns History Museum.)

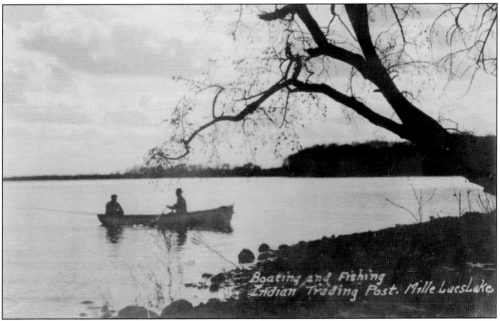

This postcard, from the Indian trading post along the shores of Mille Lacs Lake, was mailed in 1931. The message on the back describes how the clean Minnesota air made the sender sleep. Then as now, clean air and an escape from the hot summer attracted visitors from southern places. The trading post—now called the Mille Lacs Indian Museum—is still in operation today.

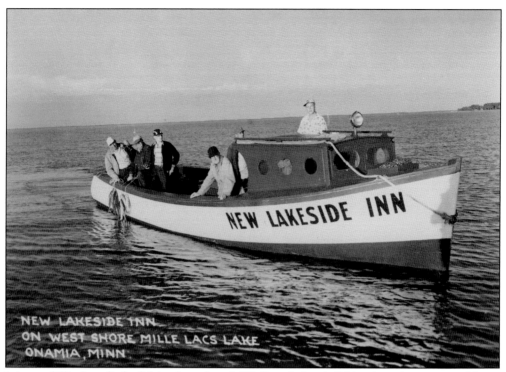

It is not difficult to find a fishing launch on Mille Lacs Lake. A fishing launch is a group fishing boat that can accommodate anywhere from six to several dozen people. The group on this launch, probably pictured in the 1950s, was having success with catching walleye.

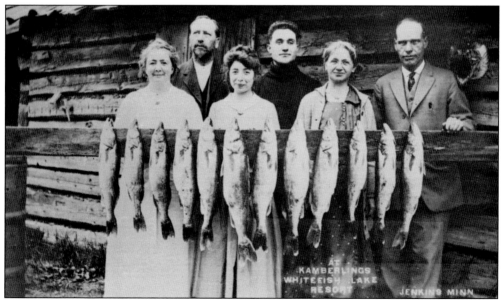

This 1920s catch of fish out of Kamberling's Whitefish Lake Resort gives an indication of what the average size of walleyes may have been in those early days. (Courtesy of Minnesota Historical Society.)

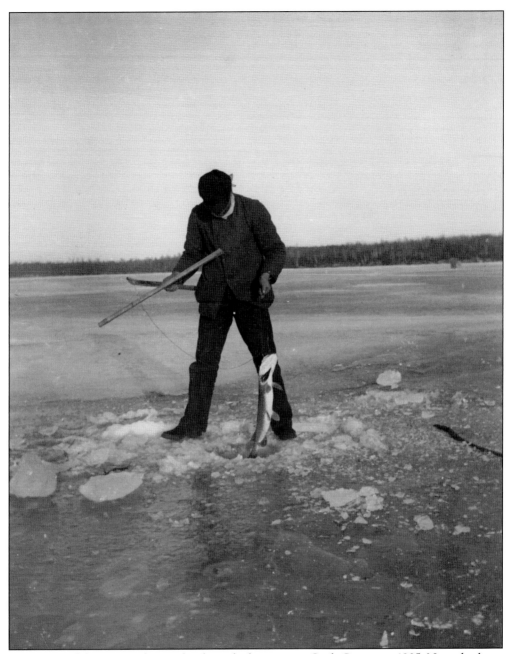

This man is lifting a northern pike through the ice near Sauk Centre in 1905. Note the large pieces of ice around the hole, indicating that it was probably chopped. Today, modern ice augers leave fine shavings instead of large pieces of ice. Long before Europeans arrived in Minnesota, Native Americans had already developed a technique for cutting holes in the ice to catch fish. (Courtesy of Stearns History Museum.)

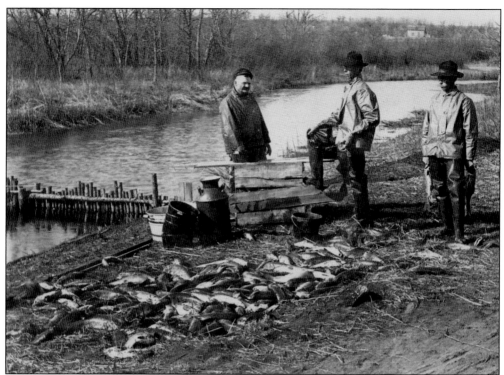

In this 1909 image, a game warden and two other men stand near a creek as they strip fish of their eggs and milt for use in a fish hatchery. Today, the Minnesota Department of Natural Resources continues to use this technique to help lakes that lack natural reproduction. About 900 lakes in the state are stocked with walleye. The discarded fish on the ground were probably rough fish. (Courtesy of Northwest Minnesota Historical Center.)

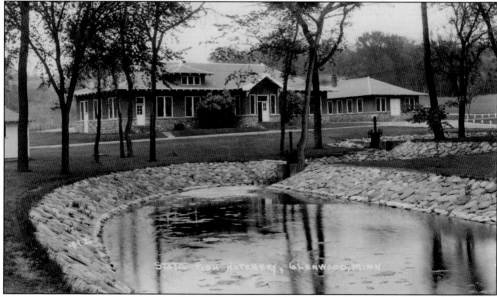

The Minnesota Department of Natural Resources fish hatchery in Glenwood was established in 1904 and is still in operation today. Every spring, up to 90 million walleye eggs are hatched here.

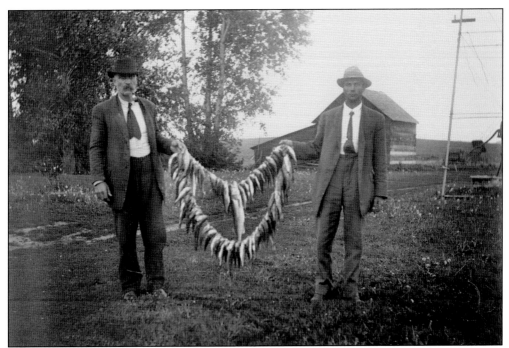

These men from the Starbuck area display a good catch of walleye and what appear to be perch in 1915. While there was no note about what lake they had fished on, Starbuck is on the western edge of the 8,000-acre Lake Minnewaska. (Courtesy of Pope County Historical Society.)

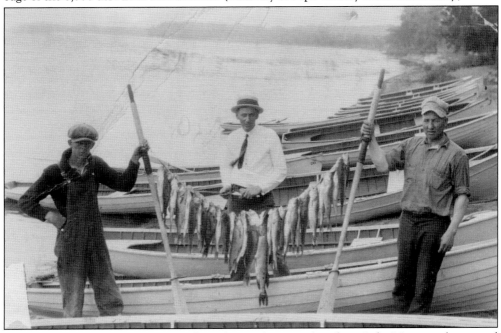

This impressive catch of walleye and northern pike was taken from Lake Minnewaska around 1915. The photograph was taken near Glenwood, which is on the eastern side of the lake. Minnewaska remains an excellent lake to catch walleye and northern pike, in addition to other species. (Courtesy of Pope County Historical Society.)

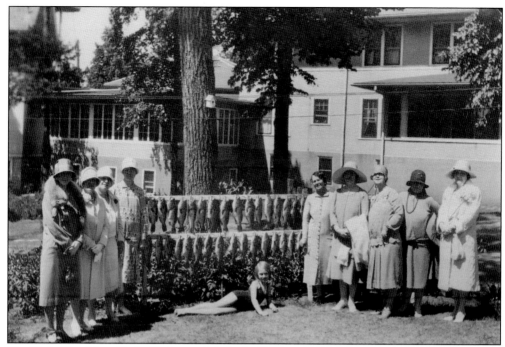

The Blake Hotel faced Lake Carlos, with Lake Le Homme Dieu on its other side. This photograph commemorating a nice catch of bass was taken outside the original hotel in 1907. A fire did substantial damage to the hotel in 1920, but rebuilding started immediately. The hotel was torn down in 1967, and the construction of townhouses on the site began in 1971. (Courtesy of Douglas County Historical Society.)

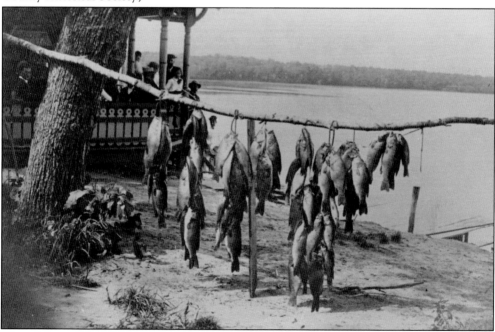

These fish were photographed at Geneva Beach Hotel around 1900. The hotel, near Alexandria, burned down on September 2, 1911. (Courtesy of Douglas County Historical Society.)

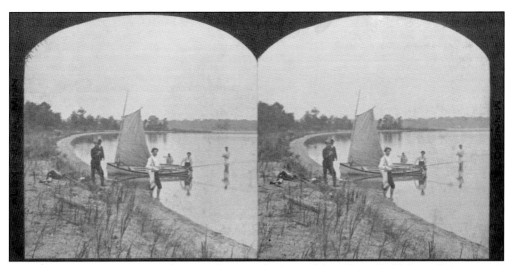

The back of this stereoscopic photograph touts the beautiful, well-stocked lakes of Minnesota's "park region"—the Alexandria area—and notes "the purity of the waters is unsurpassed, being largely supplied by springs." (Courtesy of Douglas County Historical Society.)

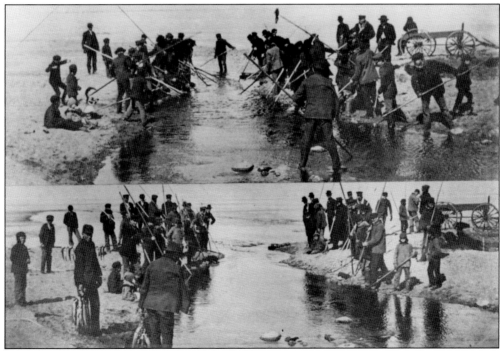

This c. 1900 double photograph shows the spearing of suckers as they pass through a narrow spot in a creek that flows into Lake Osakis. This was probably taken in springtime, when the fish crowd into creeks to spawn. (Courtesy of Douglas County Historical Society.)

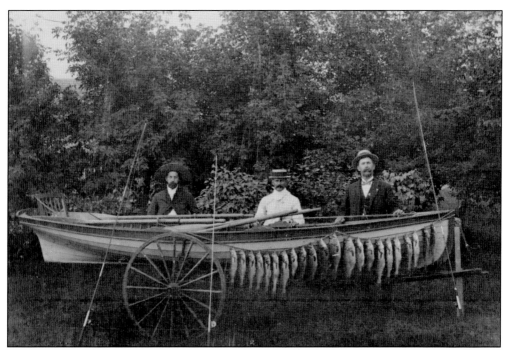

This c. 1900 photograph shows a nice catch of walleyes and bass from the Alexandria area. Modern anglers can appreciate the effort fishing must have required in those years: a trailer with spoked wheels, oars instead of an outboard motor, and no electronics. (Courtesy of Douglas County Historical Society.)

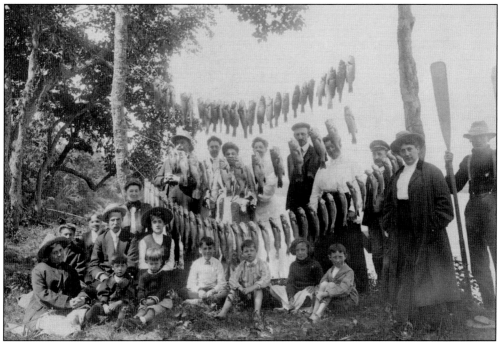

Someone took the time to meticulously arrange the bass and walleye pictured here in the Alexandria area in the early 1900s. (Courtesy of Douglas County Historical Society.)

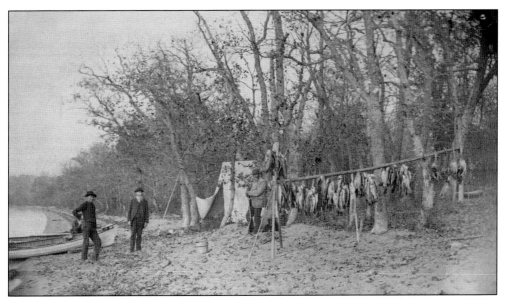

These men caught dozens of bass and several pike at their fishing camp on the east shore of Lake Miltona around 1900. The photograph shows the sandy shore common at lakes in that area. (Courtesy of Douglas County Historical Society.)

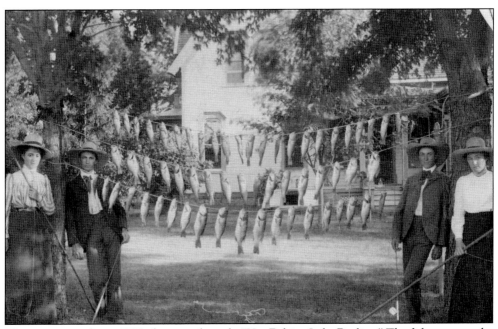

The caption on this c. 1900 photograph reads: "Hot Fishing Lake Darling." The fish appear to be bass and crappie, a typical catch in the Alexandria chain of lakes. Today, these lakes continue to offer excellent fishing conditions. (Courtesy of Douglas County Historical Society.)

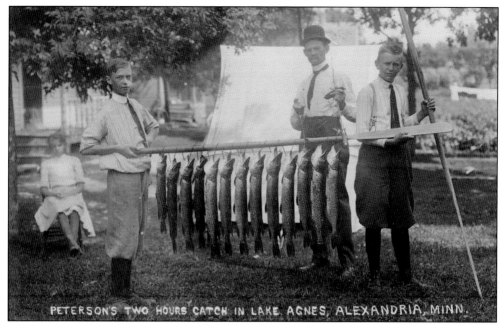

All of these northern pike were caught within a two-hour time frame on Lake Agnes in Alexandria, according to the caption on this early-1900s postcard. The lake is only 137 acres in size, but it produces decent-sized northern pike—according to the Minnesota Department of Natural Resources' lake survey from 2011, a 40-incher was netted that year. (Courtesy of Douglas County Historical Society.)

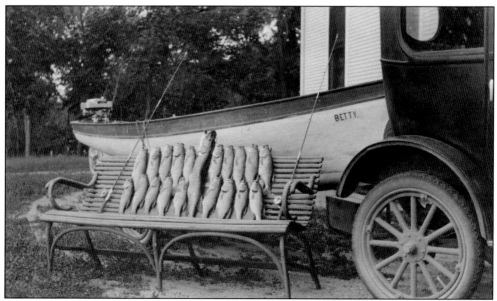

Sam Preston displays a nice catch of bass and a large pike in this 1935 photograph. Preston was one of the original members of the Alexandria Guides Association, the forerunner of today's Viking Sportsmen club. (Courtesy of Douglas County Historical Society.)

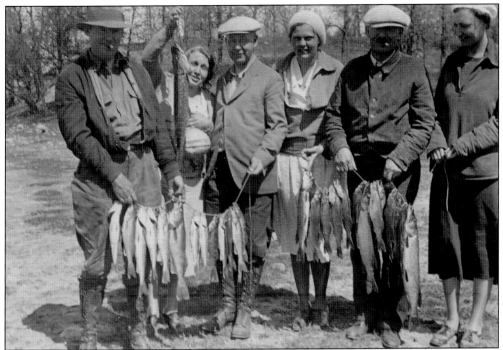

This group had good luck with walleyes and northern pike on the day when this photograph was taken (likely in the 1930s). Harold Anderson is at far left, and his wife, Lorna Anderson, is fourth from left. The Andersons operated the Travelers Inn in Alexandria for 23 years until they retired in 1965. Harold was a well-known historian. (Courtesy of Douglas County Historical Society.)

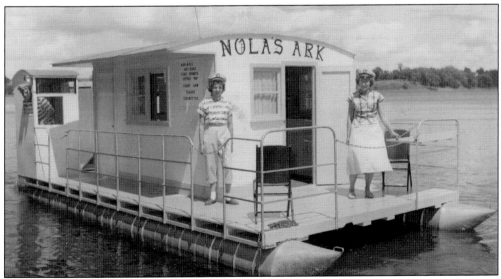

Anglers fishing on Lobster Lake (located west of Alexandria) between 1955 and the early 1970s may have seen Nola's Ark out cruising the lake. This pontoon—the floating part of Nola's Ark and Resort—was operated by Norman and Nola Foslien and served hot dogs, barbecue, and homemade doughnuts and would take people out on the lake on Sunday afternoons. (Courtesy of Douglas County Historical Society.)

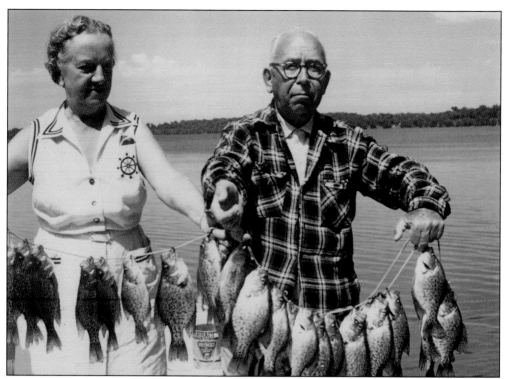

This couple displays a fine stringer of crappie caught in Lake Geneva in 1957. The lake, like many in the Alexandria area, remains an excellent crappie lake. (Courtesy of Douglas County Historical Society.)

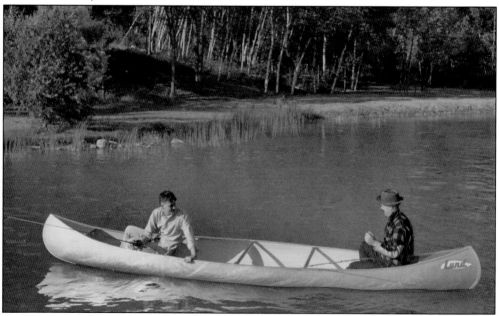

This 1968 wire photograph is captioned, "A wilderness river in Minnesota's North Woods," and was probably used to promote tourism. Many lakes and streams in Minnesota are only accessible by canoe. The canoe in this photograph was made by Lund, a company based in New York Mills.

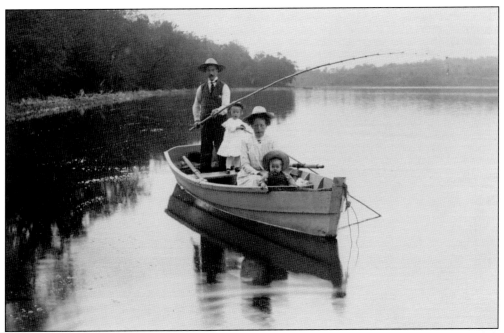

This family may have been more interested in getting a good group photograph than catching fish on a lake near Clitherall in the early 1900s. In either case, it is nice to spend the morning on a lake so calm that the water looks like glass. (Courtesy of Northwest Minnesota Historical Center.)

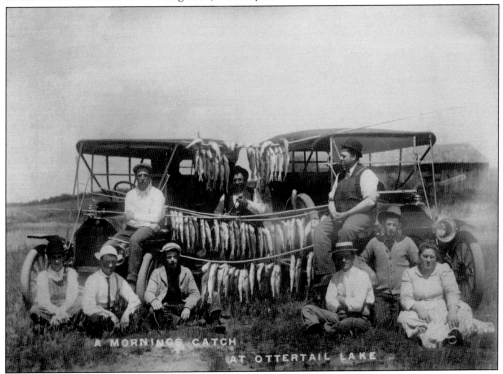

A MORNINGS CATCH AT OTTERTAIL LAKE

This group must have had fun catching walleye in the morning on Otter Tail Lake in the early 1900s. The lake remains popular for walleye angling and is also managed for lake sturgeon.

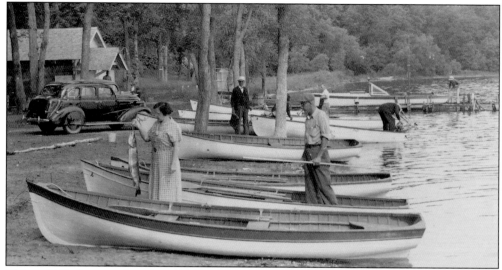

This c. 1940 photograph is from Bowen's Resort, located on Big Pine Lake near Perham. Based on the styling, the wooden rowboats were possibly built by Alexandria Boat Works, one of many area boat manufacturers operating in the early 1900s. These boats, with the trade name "Lady of the Lakes," were often sold within a small radius of Alexandria.

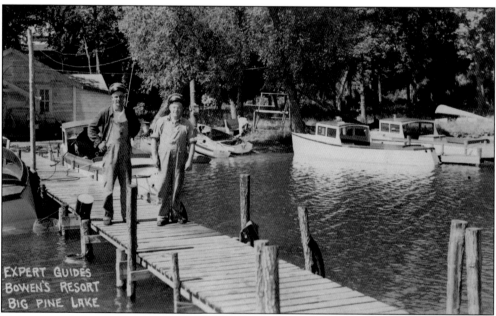

This postcard shows two of the expert guides at Bowen's Resort. Many resorts offered guide service to ensure guests had successful outings. (Courtesy of the History Museum of East Otter Tail County.)

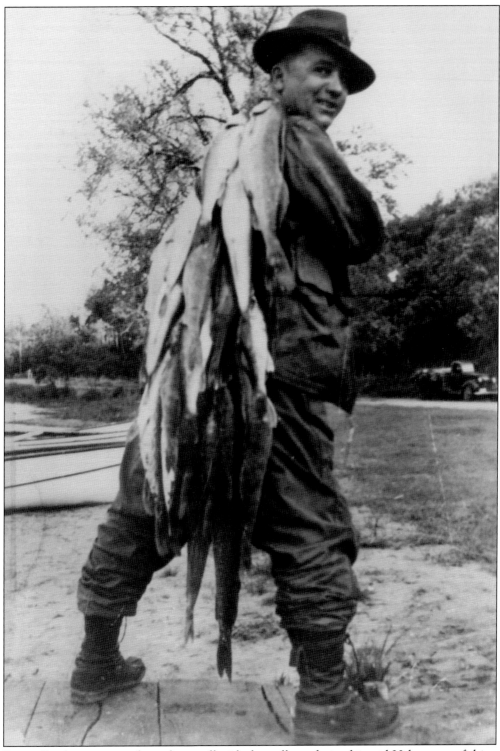

Duane Donley appears to have done well with the walleyes during his mid-20th-century fishing trip in the Perham area. (Courtesy of the History Museum of East Otter Tail County.)

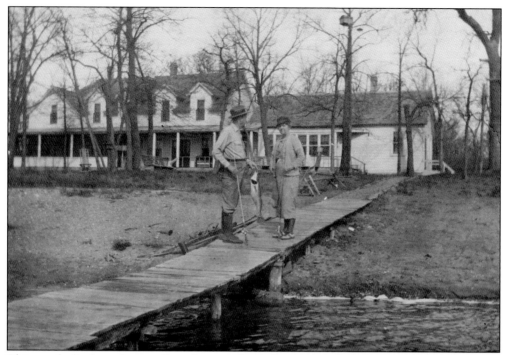

This couple displays a large walleye they caught while staying at Marion Lake Lodge, which is in the background. (Courtesy of the History Museum of East Otter Tail County.)

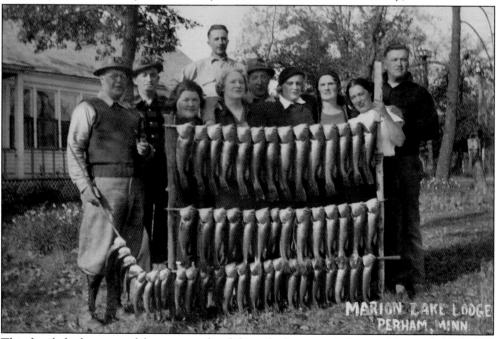

This family had a successful outcome after fishing for largemouth bass at Marion Lake Lodge. The lodge was built around 1900. There were rumors that gangsters stayed at the lodge in the early days, which may have contributed to the frequent changes in ownership. The lodge was torn down in 1972. (Courtesy of the History Museum of East Otter Tail County.)

Tommy and Bea Swenteck were the managers of Mosquito Heights, on Big Pine Lake, in the early 1900s. The resort is now called Big Pine Lodge. (Courtesy of the History Museum of East Otter Tail County.)

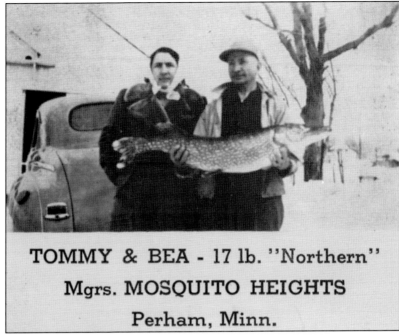

TOMMY & BEA - 17 lb. "Northern"
Mgrs. MOSQUITO HEIGHTS
Perham, Minn.

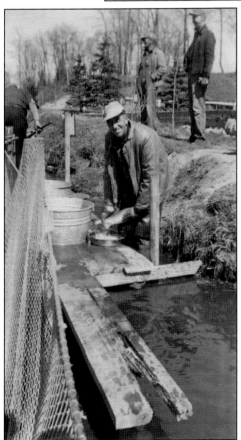

In this 1940s photograph, Art Stilke harvests walleye eggs and milt, probably near Pelican Lake in Otter Tail County, for use in a walleye hatchery. (Courtesy of Becker County Historical Society.)

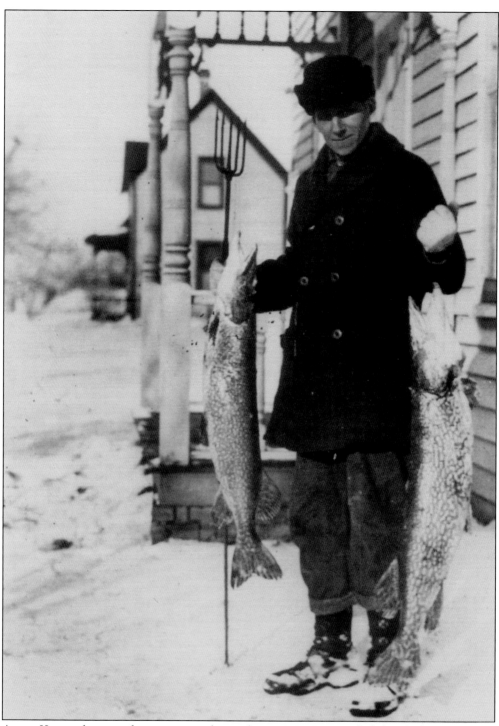

Anton Kentowski speared two giant northern pike in 1942. Notes included with the photograph stated that one weighed 30 pounds. Note the spear in his right hand; spearing northern pike is still practiced today and involves using a decoy to bring pike near a hole in the ice. (Courtesy of the History Museum of East Otter Tail County.)

Four

NORTHWEST REGION

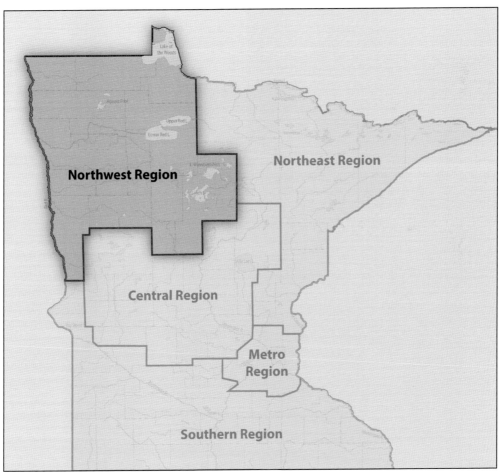

The northwest region was partially covered by glacial Lake Agassiz thousands of years ago, leaving behind a large area of flatland. Today, the region includes a 500-square-mile peat bog, the largest in the lower 48 states. It is also home to most of Minnesota's largest lakes, including Lake of the Woods, Upper and Lower Red Lakes, Leech Lake, and Lake Winnibigoshish.

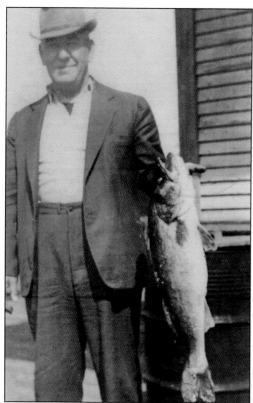

This 12-pound walleye was caught by N.O. Stadum near Warroad around 1942. The fish was probably from Lake of the Woods, which covers more than one million acres and contains more than 14,000 islands.

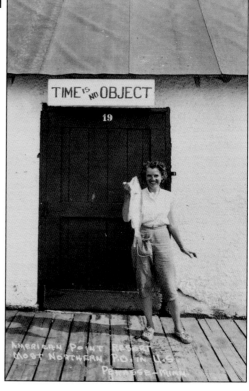

This angler displays a large Lake of the Woods walleye in this 1930s postcard. The caption says, "American Point Resort/ Most Northern P.O. in U.S./Penasse, Minn." This was true until Alaska became a state in 1959. However, Penasse is still the northernmost populated place in the contiguous United States. (Courtesy of Minnesota Historical Society.)

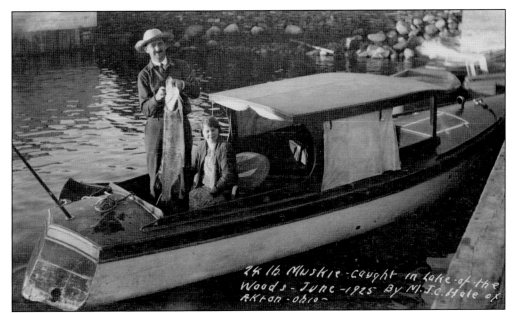

The lakes of Minnesota have long been known for their ability to produce large muskellunge, also called muskie. According to the caption, this 24-pounder was caught in Lake of the Woods in June 1925 by M.J.C. Hale of Akron, Ohio. With minimum size limits and with more anglers practicing catch-and-release, many of these big fish can still be found in the state's lakes. (Courtesy of Minnesota Historical Society.)

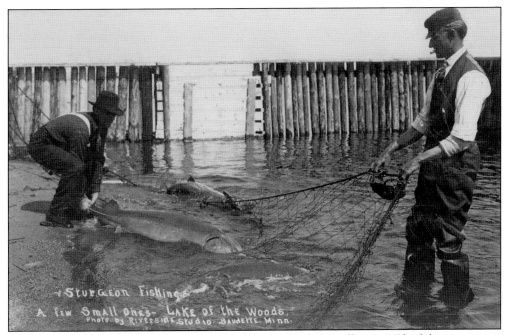

The writing on this 1911 postcard sarcastically says: "A few small ones." The lake sturgeon is actually Minnesota's largest fish, and there are still some giants swimming in Lake of the Woods today. (Courtesy of Northwest Minnesota Historical Center.)

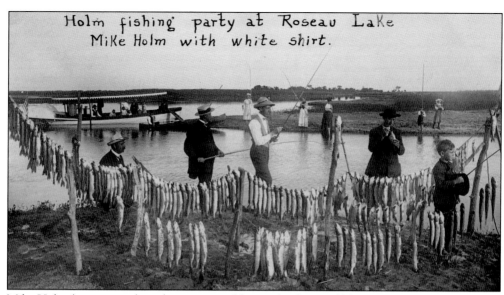

Holm fishing party at Roseau Lake
Mike Holm with white shirt.

Mike Holm (center, in white shirt, vest, and bow tie), who would later become the secretary of the state of Minnesota, was part of this Holm family fishing party on Roseau Lake around 1900. Roseau Lake was drained in a flood-control project not long after this photograph was taken. (Courtesy of Roseau County Historical Society, Holm collection.)

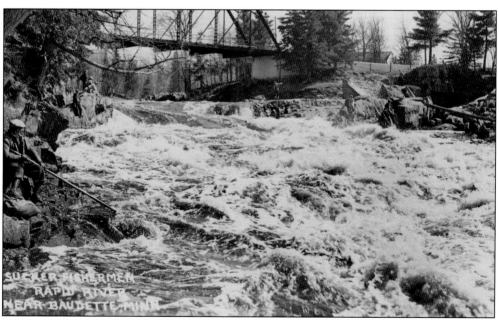

SUCKER FISHERMEN
RAPID RIVER
NEAR BAUDETTE MINN

On this 1939 postcard, anglers use long-handled dip nets to catch suckers in the Rapid River near Baudette.

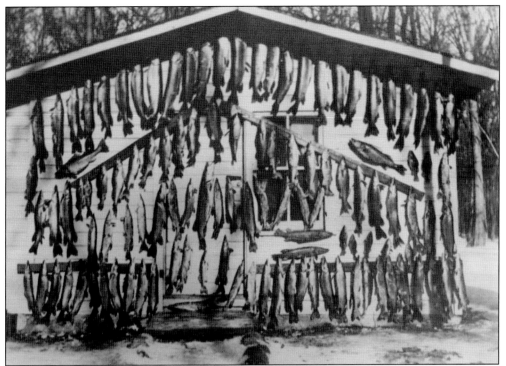

At over 56,000 acres, Lake Winnibigoshish—or Lake Winnie, as the locals call it—is the fourth-largest lake in Minnesota and is considered one of its premier fishing lakes. In 1931, the exterior wall of this cabin offers evidence that Clem Kost and his friends had a spectacular day of fishing for walleye and northern pike. (Courtesy of Stearns History Museum.)

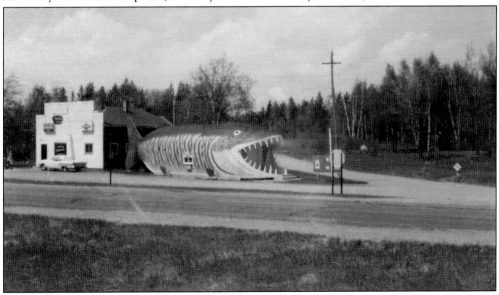

The Big Fish Supper Club, near Bena, became famous when it appeared in the opening credits of National Lampoon's *Vacation*. This photograph was taken in 1959, not long after the structure was originally built as a snack stand. The fish was recently restored and remains a popular roadside icon. (Courtesy of Gene Fries.)

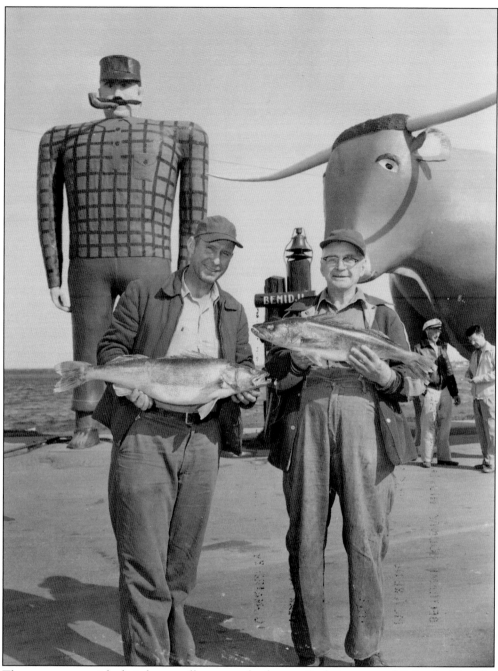

These men pose with their large walleye near the famous Paul Bunyan and Babe the Blue Ox statues. Originally built in the late 1930s, the statues continue to greet tourists and anglers in the Bemidji area. (Courtesy of Beltrami County Historical Society.)

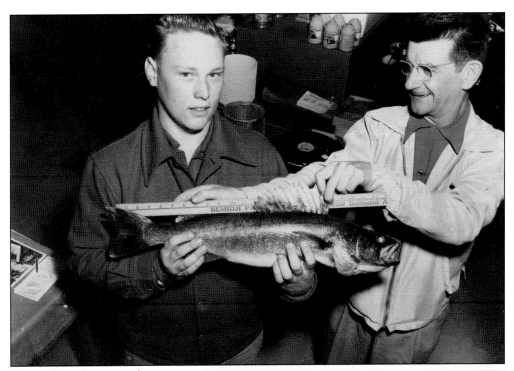

The walleye above, caught in the Bemidji area in the mid-20th century, measured about 24 inches. Walleye are easily recognizable because of the white spot on the bottom tip of their tails. (Courtesy of Beltrami County Historical Society.)

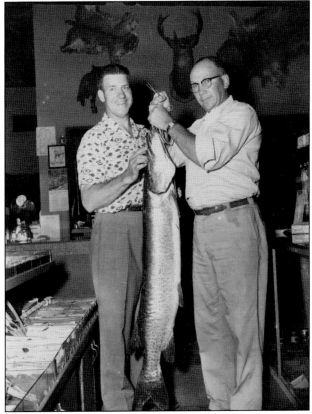

This muskellunge probably measured around 50 inches. This is one of several photographs in this book believed to have been displayed in the front window of Lund & Kroll Sporting Goods, established in 1946 in downtown Bemidji. The store, which closed in the 1980s, displayed many photographs of people—often tourists with their local catches. (Courtesy of Beltrami County Historical Society.)

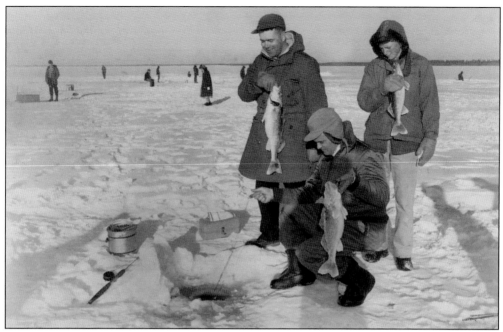

This photograph was most likely taken to promote ice fishing and winter activities in Minnesota. The "fishing line" going from the angler's hand to the hole in the ice was drawn on the photograph; it would also be unusual to find a group of anglers all holding their catches while fishing. (Courtesy of Beltrami County Historical Society.)

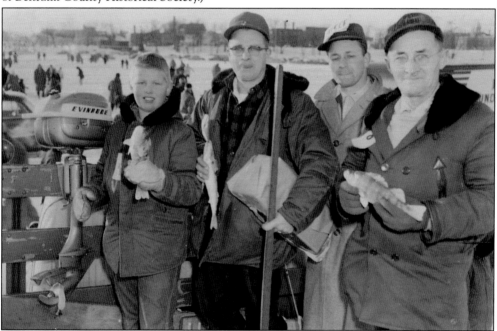

These fellows appear to be the winners of a mid-20th-century ice-fishing contest in the Bemidji area. The state hosts hundreds of these contests, especially in January and February, as the ice can become several feet thick in those months, which makes it safer to walk and drive on. (Courtesy of Beltrami County Historical Society.)

This massive bluegill, caught in the mid-20th century in the Bemidji area, appears to exceed 10 inches. While there are still ample populations with some large bluegills in the state's waters, catches like this are less common today. (Courtesy of Beltrami County Historical Society.)

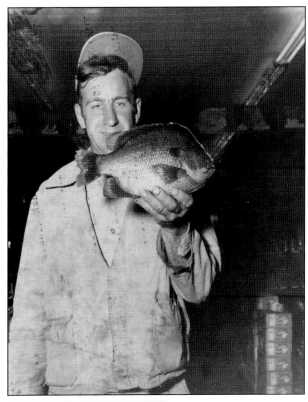

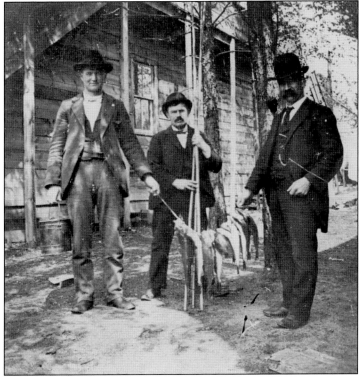

Charlie Schroeder (left) and his friends had a good outing in the Bemidji area in the early 1900s. Note the long cane poles held by the man in the center. (Courtesy of Beltrami County Historical Society.)

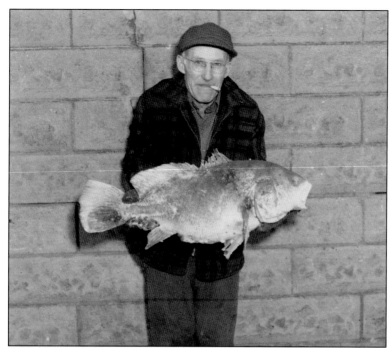

The fish in this mid-20th-century photograph from the Bemidji area appears to be a large freshwater drum. While some people find the drum tasty, most anglers do not keep them. (Courtesy of Beltrami County Historical Society.)

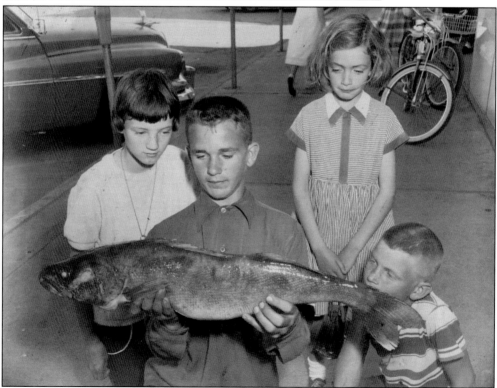

This walleye from the Bemidji area was likely around 30 inches long. Due to limits that reduce the harvest of large walleye, there are still plenty of these trophy fish in the state's waters. (Courtesy of Beltrami County Historical Society.)

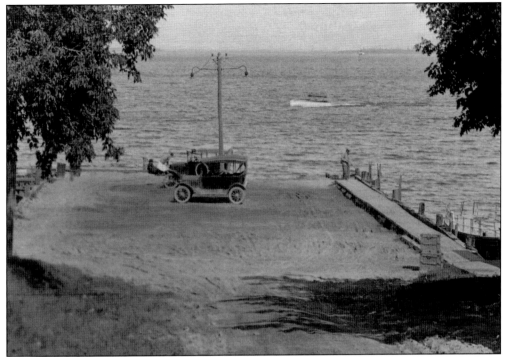

Most fishing lakes in the state have public water access, such as this dock on Leech Lake, near Walker. The US Army Corps of Engineers issued a license in 1913 for a public boat landing at Leech Lake. Today, the Minnesota Department of Natural Resources maintains most of the public accesses.

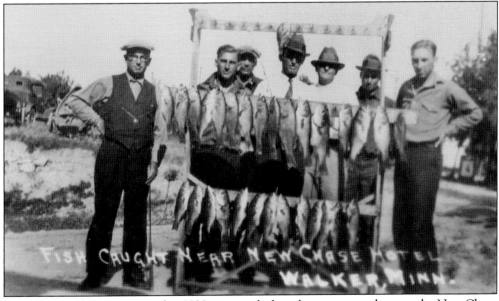

According to the caption on this 1930s postcard, these bass were caught near the New Chase Hotel on Leech Lake. The hotel opened in 1922 and went through several ownership changes. It was destroyed by fire on June 29, 1997. The hotel was completely restored and remodeled and then reopened in June 2008. (Courtesy of Minnesota Historical Society.)

Impressive stringers of fish like this one have long attracted visitors to the Leech Lake area. Note that the women are standing on blocks in an attempt to keep the fish above the floor. (Courtesy of Cass County Historical Society.)

Walleye and northern pike were the target species for these young men during an outing in the Walker area. (Courtesy of Cass County Historical Society.)

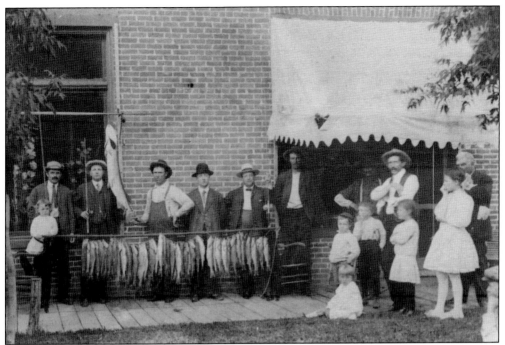

This fishing party, guided by Bob Ross, caught a nice stringer of walleye in 1906 on a lake in the Walker area. Note the large muskellunge hanging above the walleye. Anglers often unintentionally catch muskellunge while fishing for other species. (Courtesy of Cass County Historical Society.)

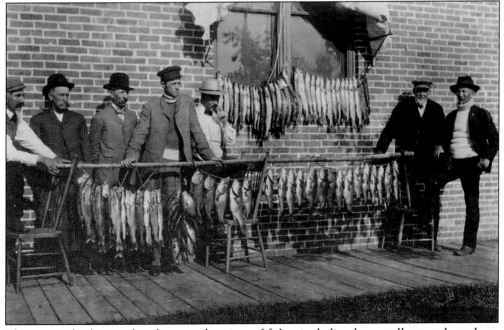

These men display an abundance and variety of fish—including bass, walleye, and northern pike—in this early photograph from the Leech Lake area. It is common for lakes in the state to contain a dozen or more species of fish. (Courtesy of Cass County Historical Society.)

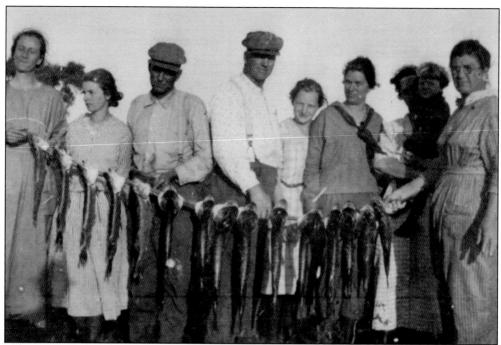

"A days fishing with friends" is written on the back of this 1920 photograph from the Cass County area. (Courtesy of Cass County Historical Society.)

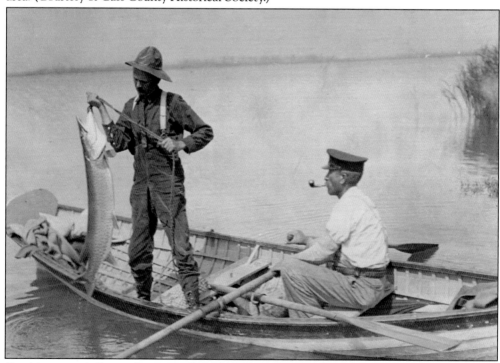

Catching a muskellunge from a small rowboat was undoubtedly more of a challenge than what anglers experience today while riding in large, gas-powered boats and using modern tackle. (Courtesy of Cass County Historical Society.)

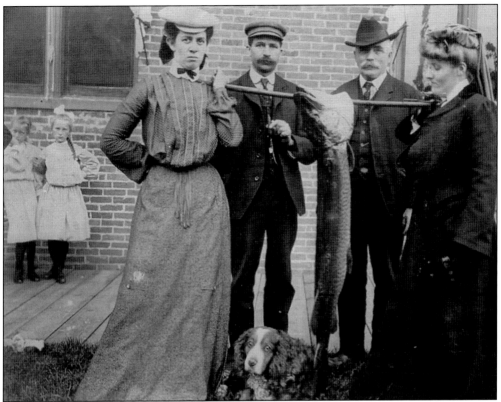

Members of the Kuhlander family display a large muskellunge in this early photograph from the Cass County area. (Courtesy of Cass County Historical Society.)

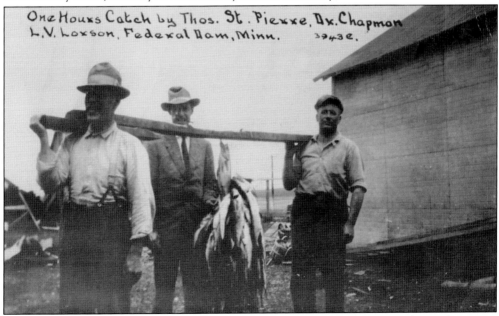

All these fish—probably walleye and northern pike—were caught in one hour, according to the caption on this 1923 photograph. The location was Federal Dam, a small town near Leech Lake.

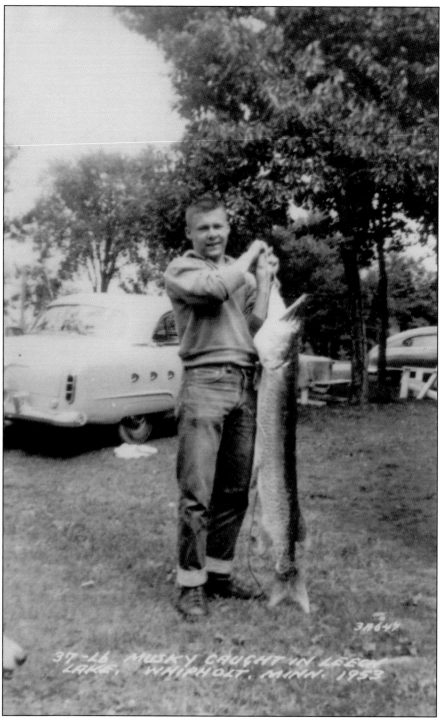

This 37-pound monster muskellunge was caught on Leech Lake in 1953 and photographed in the Whipholt area. At over 110,000 acres, Leech Lake is the third-largest lake entirely within Minnesota and is known for offering some of the best walleye and muskellunge fishing in the Midwest. (Courtesy of Cass County Historical Society.)

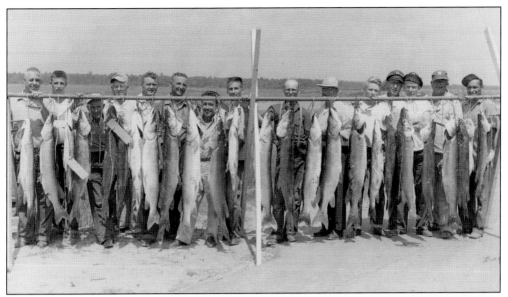

In the middle of July in 1955, muskellunge on Leech Lake went on an unusual feeding frenzy that became known as the "1955 Muskie Rampage." This photograph shows 25 of the 51 muskellunge brought into the town of Federal Dam on July 16 and 17. (Courtesy of Cass County Historical Society.)

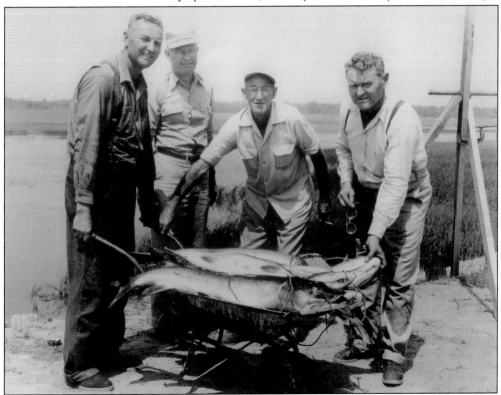

Garry Neururer, a launch operator out of Federal Dam, holds the handles of this wheelbarrow load of muskellunge caught during the 1955 Muskie Rampage. (Courtesy of Cass County Historical Society.)

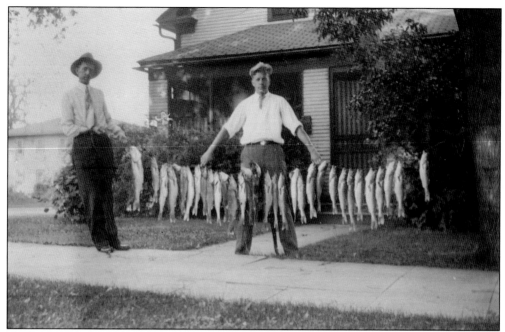

The walleye in this June 1931 image were caught on Leech Lake out of Forest View Lodge. The photograph was taken in Minneapolis, presumably after these anglers returned home. (Courtesy of Cass County Historical Society.)

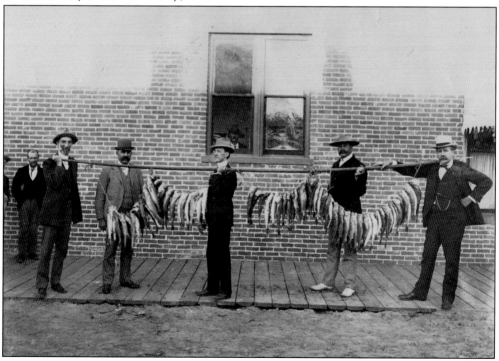

These early anglers needed a long pole to display their catch of walleye. The exact year of this photograph is unknown, but the wooden sidewalks date it to the early 1900s. (Courtesy of Cass County Historical Society.)

While Leech Lake is well known for walleye and muskellunge, it also has plenty of northern pike—some of which are quite large. This early photograph shows part of a morning's catch. The fish shown had a total weight of 93 pounds. (Courtesy of Cass County Historical Society.)

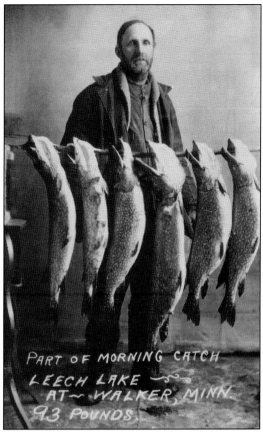

Walker-area lakes, including Leech Lake, have long been home to big perch, as seen in the mid-20th-century photograph below. (Courtesy of Cass County Historical Society.)

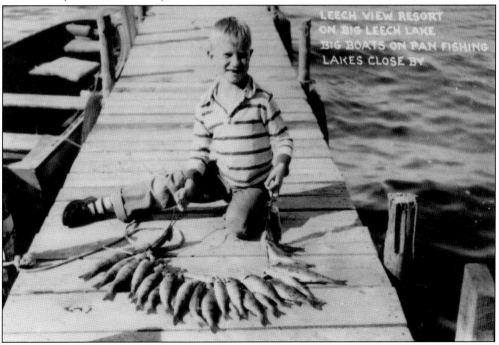

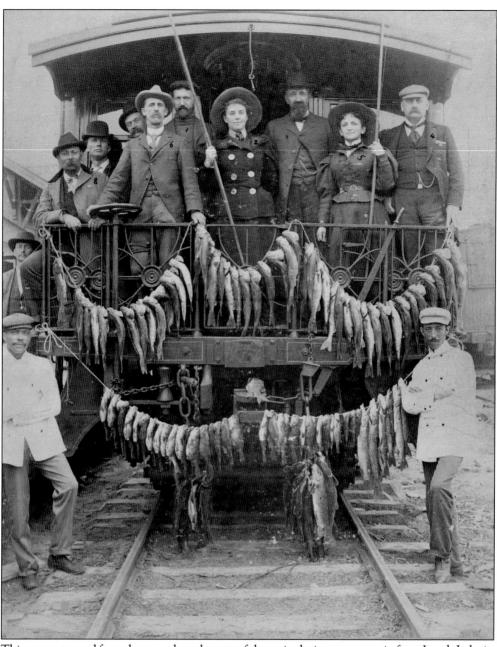

This group stopped for a photograph at the rear of the train during a return trip from Leech Lake in 1896. The railroad had just arrived in Walker, opening the area to tourism. Walleye, bass, and northern pike are among the species displayed here. (Courtesy of Minnesota Historical Society.)

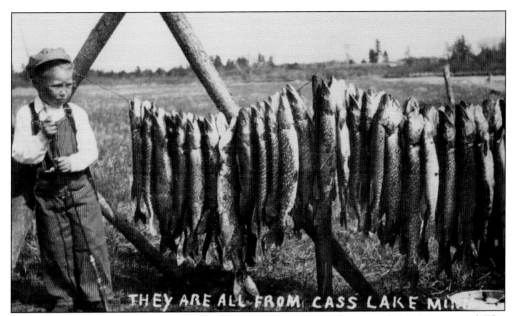

Cass Lake has long been known as a good northern pike lake, as shown on this 1920s postcard. The lake was originally named Red Cedar Lake, but the name was later changed to honor Michigan Territory governor Lewis Cass, who explored the area in the early 1800s and believed the lake to be the source of the Mississippi River. In 1832, Henry Schoolcraft led a second expedition to the area and determined that Lake Itasca is the true source of the Mississippi River. (Courtesy of Minnesota Historical Society.)

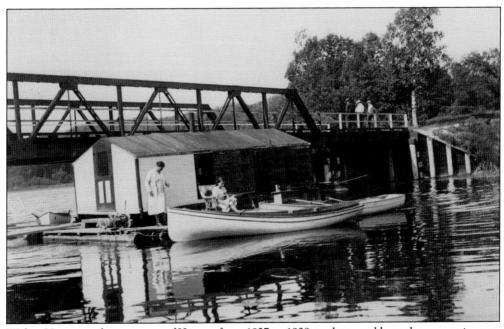

Walter Huxman, the governor of Kansas from 1937 to 1939, took several houseboat vacations on the Turtle River near Bemidji. Huxman's wife, Eula, and their daughter Ruth (right) are pictured in this 1933 photograph.

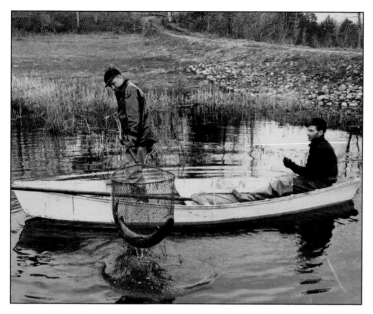

A muskellunge hatchery was built on the shores of Lake Belle Tain, in Nevis, around 1940. This photograph from around 1950 shows hatchery employees netting a muskellunge ready to yield her eggs. Today, the hatchery is gone and Lake Belle Tain is no longer known as a muskellunge destination, although it is known for having rare silver pike, a "color phase" of the northern pike. (Courtesy of Minnesota Historical Society.)

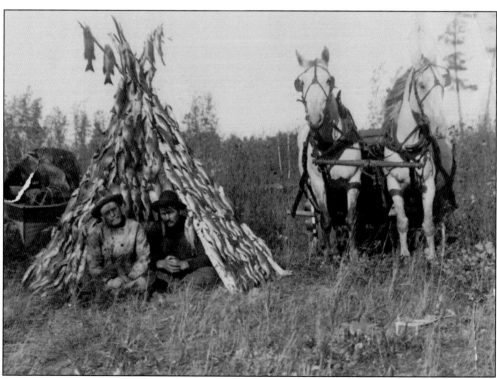

In this c. 1905 photograph, William H. McCart and Dr. Fry (both from St. Paul) display—in the shape of a teepee—the bass they caught on Island Lake in Becker County over a two-week period. (Courtesy of Becker County Historical Society.)

90

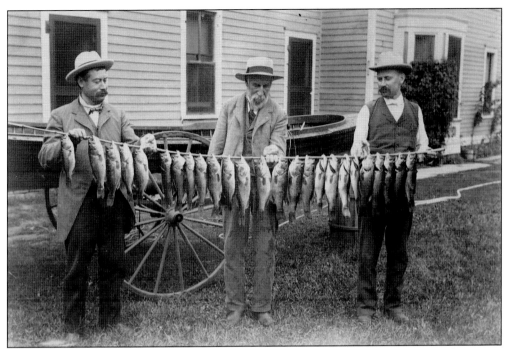

A catch of bass like this was common around 1900 in the Becker County area. Note the wagon wheel–style boat trailer. (Courtesy of Becker County Historical Society.)

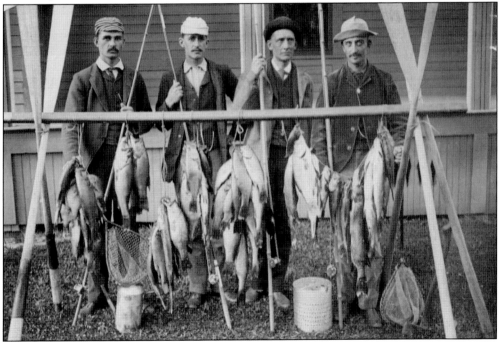

This early photograph shows a nice catch of bass, northern pike, and bluegills displayed at the Sargent House in Detroit Lakes. The house, built by Gen. Homer E. Sargent in the late 1880s, is still in use today as a private residence and is listed in the National Register of Historic Places. (Courtesy of Becker County Historical Society.)

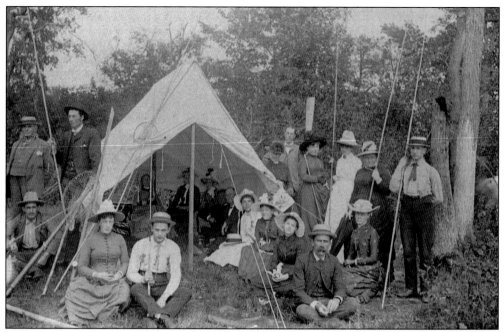

The caption on this 1887 photograph simply says: "Sargent's fishing camp." "Mr. Sargent" was written next to the man standing at far left. (Courtesy of Becker County Historical Society.)

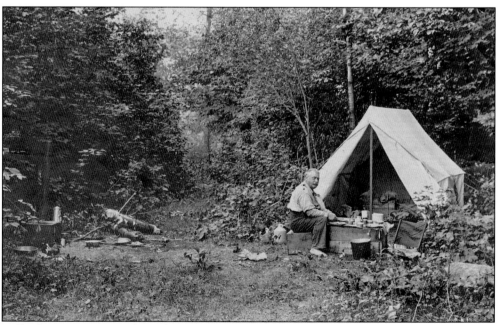

Millard Howe was an early settler in Becker County. An official guide and the head cook for fishing and hunting parties, he is pictured here at a camp on Strawberry Lake. (Courtesy of Becker County Historical Society.)

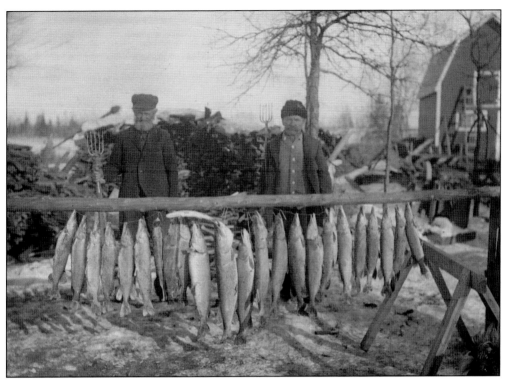

These two men caught about two dozen northern pike in Murphy Lake, just east of the town of Frazee, on April 1, 1900. The men are holding spears, meaning that the fish were presumably speared through holes in the ice. (Courtesy of Becker County Historical Society.)

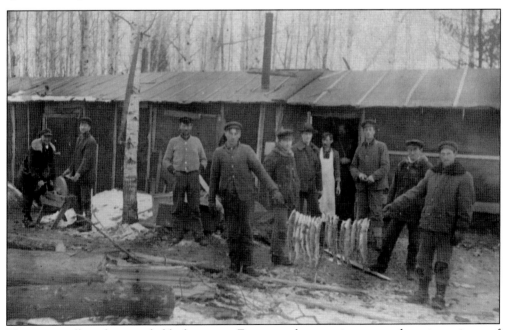

These sawmill workers, probably from near Frazee, took some time to catch a nice stringer of northern pike one winter in the early 1900s. (Courtesy of Becker County Historical Society.)

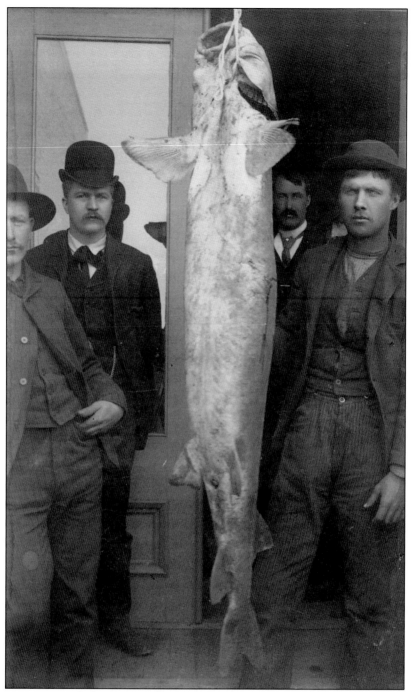

This sturgeon was caught by means other than hook and line from Detroit Lake in April 1890. It weighed 120 pounds and was six feet and four inches in length. According to the Minnesota Department of Natural Resources, Detroit Lake was known to contain lake sturgeon weighing over 100 pounds in the late 1800s and early 1900s, but a variety of factors resulted in the loss of the species in the lake. Today, through stocking and various water-quality improvements, lake sturgeon once again swim in Detroit Lake. (Courtesy of Becker County Historical Society.)

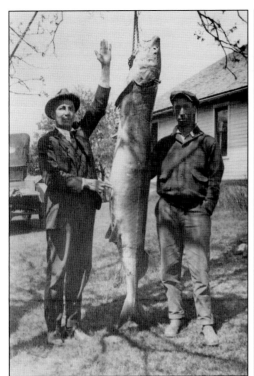
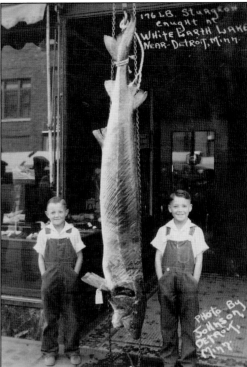

These are two photographs of the same fish—a 176-pound, 87-inch lake sturgeon taken from White Earth Lake in 1926. Notes with the photographs indicate that the fish was "trapped" rather than caught with a hook and line. (Courtesy of Becker County Historical Society.)

Judges of the winter fishing derby on Lake Sallie, in Becker County, pose with some nice-sized walleyes. Because of frequent stocking, the lake continues to be a good destination for those fishing for walleye. (Courtesy of Becker County Historical Society.)

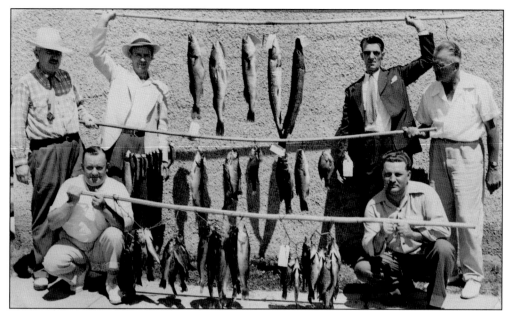

A fishing contest held in the Becker County area in July 1943 yielded these fish, including some northern pike, walleye, bass, crappie, and bluegills. This is a fairly standard list of game fish found in many Minnesota lakes. (Courtesy of Becker County Historical Society.)

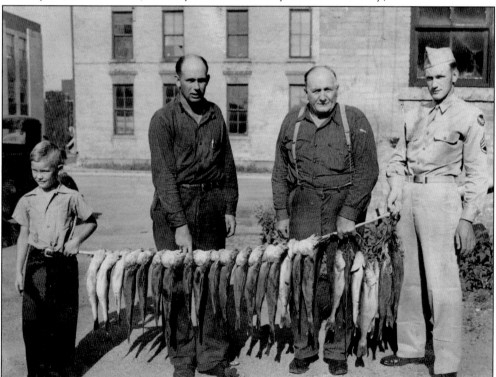

Staff Sgt. Adolph Hafner (far right) is pictured here with his father and son and one other unidentified person. It appears that they had a great day of walleye fishing in the Detroit Lakes area on July 15, 1943. (Courtesy of Becker County Historical Society.)

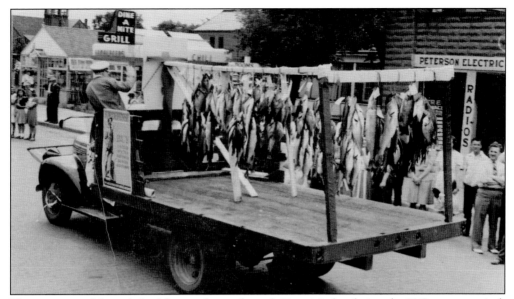

These winning fishing derby fish were driven through Detroit Lakes during the 1942 water carnival. The poster on the side of the truck is a reminder of that time that reads, "For Defense Buy United States Savings Bonds and Stamps." (Courtesy of Becker County Historical Society.)

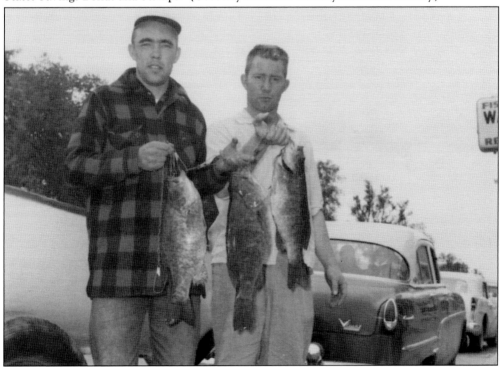

The heaviest of these smallmouth bass (caught in the Detroit Lakes area in the mid-20th century) topped six pounds. Combined, the three fish weighed over 15 pounds. Smallmouth bass are native to the Mississippi River watershed and are considered by many anglers to be—pound for pound—the strongest fighting fish. Thanks to stocking programs, smallmouth bass became abundant throughout central and northern Minnesota. (Courtesy of Becker County Historical Society.)

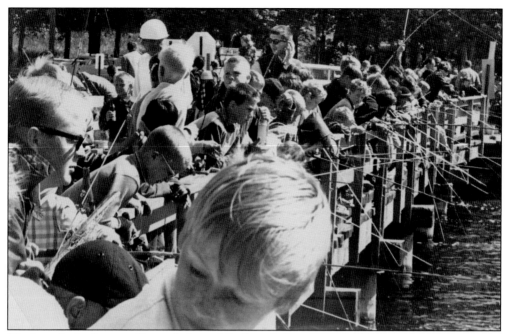

The Long Bridge between Detroit Lake and Curfman Lake is a popular fishing spot, as shown in this photograph (presumably of a fishing event). (Courtesy of Becker County Historical Society.)

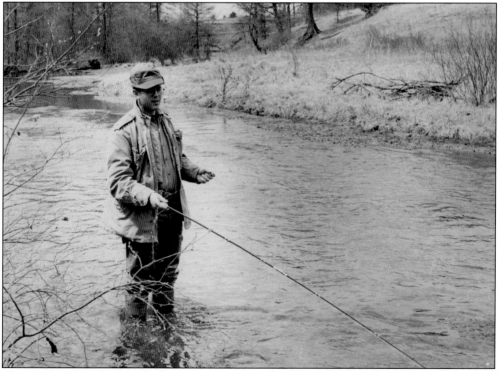

This angler fishes the Straight River near Osage in the spring of 1963. The Straight River is fed by many springs, which provide the cold water needed to support a trout population. (Courtesy of Becker County Historical Society.)

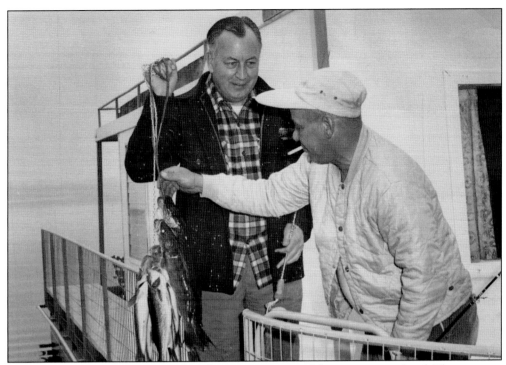

Gov. Elmer Andersen (left) did well in the 1962 Minnesota fishing opener weekend. The governor reportedly fished on Detroit Lake and Island Lake. The annual Governor's Fishing Opener is a state tradition that happens each May. (Courtesy of Becker County Historical Society.)

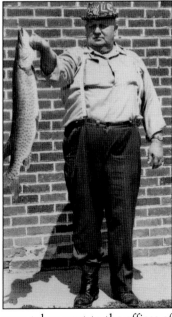

These photographs of trophy northern pike and muskellunge were taken next to the offices of the *Farmers Independent* newspaper in Bagley. In many communities, it was typical for fish to be weighed and photographed in a designated spot—often in front of angling-related businesses or newspapers. (Courtesy of Clearwater County Historical Society.)

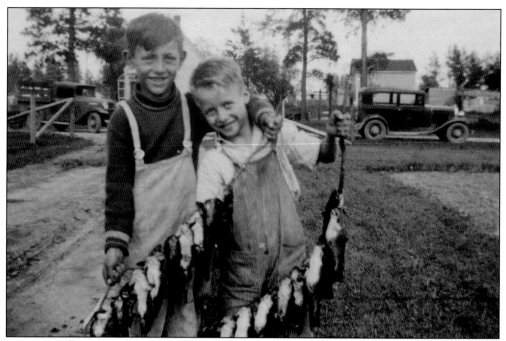

These boys smile as they show off their catch of bullheads near Bagley around 1930. While many consider the bullhead tasty, it is often thrown back; perhaps this is because of its less than appetizing name and appearance. (Courtesy of Clearwater County Historical Society.)

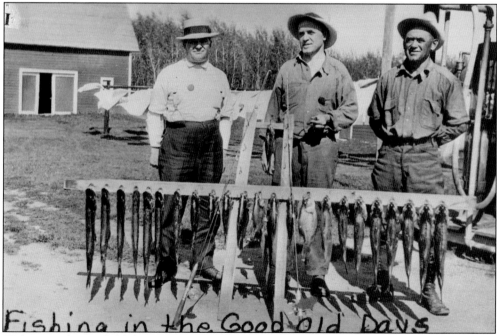

"Fishing in the good old days" reads the caption on this photograph taken at Snyder's Resort on Lake Itasca in the early 1900s. Thanks to stocking, minimum size limits, and more catch-and-release fishing of large egg-producing fish, outings like this are still possible today. (Courtesy of Clearwater County Historical Society.)

Five

NORTHEAST REGION

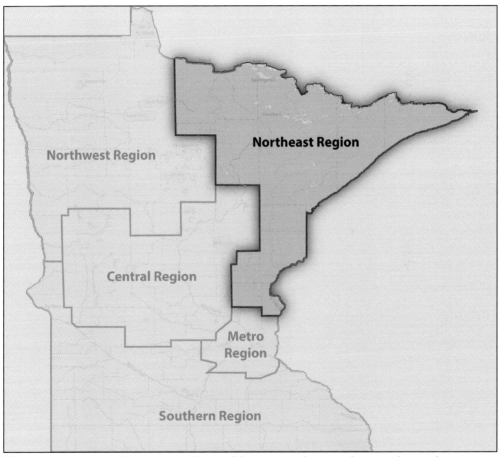

The northeast region is the most rugged part of the state; it is home to the state's lowest elevation—at Lake Superior, 600 feet above sea level—and its highest elevation, at 2,301 feet, only 15 miles away from Lake Superior. As one drives north into this region, the land becomes increasingly rocky. Many of the lakes in the area are deep and cold, with water clarity sometimes exceeding 20 feet. Due to its distinct shape, formed by the Canadian border and the north shore of Lake Superior, this part of the state is often called "the arrowhead."

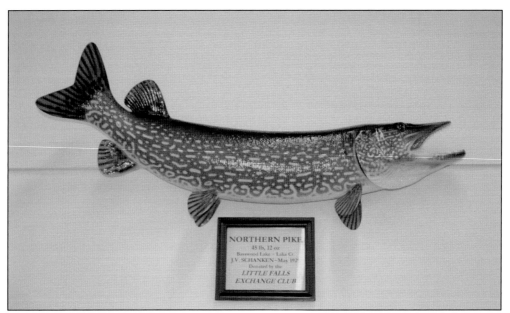

This replica at the Minnesota Fishing Museum in Little Falls is one of the few glimpses available of John V. Schanken's record northern pike. Schanken caught the fish—which weighed 45 pounds and 12 ounces—on May 16, 1929, in Basswood Lake. A photograph of the fish appeared in a Chicago newspaper, but the whereabouts of that photograph (or a photograph submitted to a fishing contest held by *Field & Stream* magazine at the time) are unknown. (Courtesy of Minnesota Fishing Museum.)

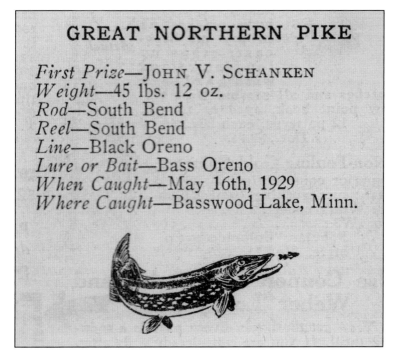

GREAT NORTHERN PIKE

First Prize—JOHN V. SCHANKEN
Weight—45 lbs. 12 oz.
Rod—South Bend
Reel—South Bend
Line—Black Oreno
Lure or Bait—Bass Oreno
When Caught—May 16th, 1929
Where Caught—Basswood Lake, Minn.

The March 1930 issue of *Field & Stream* announced John V. Schanken's northern pike as the winner of its annual northern pike fishing contest. The magazine also noted that the fish set a new world record. The fish remains Minnesota's record largely based on *Field & Stream*'s recognition. Little else is known about the fish or Schanken, although he was from Chicago and lived in Minnesota in his later years.

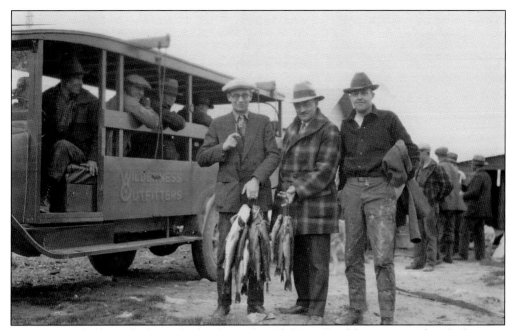

James Laing (left), guide Oscar Bodin (center), and Oscar Friedsburg returned with this nice catch of walleye from a businessmen's trip to Basswood Lake as guests of Wilderness Outfitters in Ely. Wilderness Outfitters began in 1921 and was responsible for the operation of a mechanized portage connecting Ely and nearby Fall Lake to Basswood Lake. (Courtesy of Ely-Winton History Museum.)

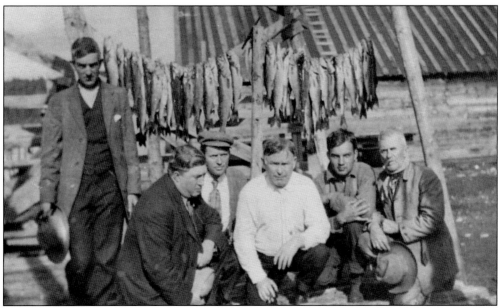

Basswood Lake was a popular destination for walleye and northern pike in the early 1900s and remains so today. The lake encapsulates more than 22,000 acres and runs along Minnesota's border with Canada. (Courtesy of Ely-Winton History Museum.)

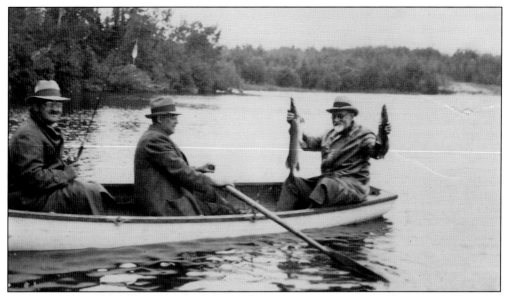

Sen. Joseph Ransdell of Louisiana (right) visited Minnesota in 1928, according to an account in Leslie R. Beatty's *A Forest Ranger's Diary*. Senator Ransdell was attending public hearings regarding the building of dams that would impact the waters along the Minnesota-Canada border. It is unknown if this photograph was taken during that trip or in subsequent years. Also in the boat are Oscar Bodin (left), an Ely guide, and Lake County commissioner August Omtvedt. (Courtesy of Ely-Winton History Museum.)

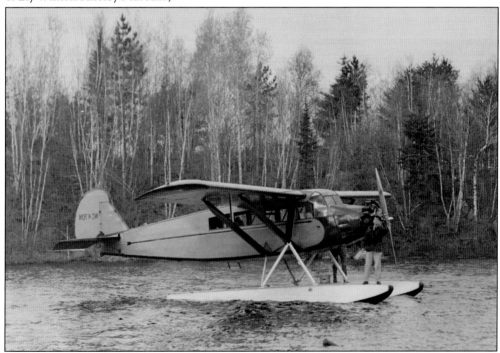

This photograph from the Minnesota Tourist Bureau has an accompanying caption that states, "Getting set to cast from the seaplane for those scrappy game fish which abound in virgin fishing waters on Minnesota's north border only recently made accessible for anglers by the seaplane."

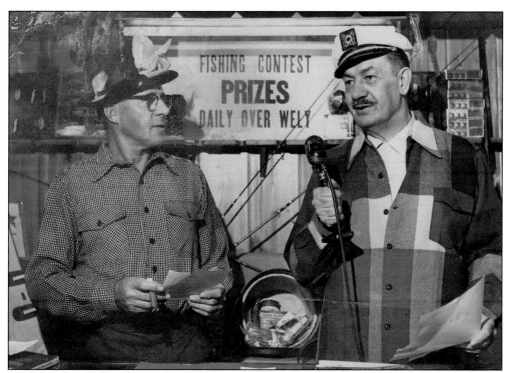

Ely visitors come for the boundary water's scenery and the fishing. Many visitors are familiar with WELY, the local radio station, which has been broadcasting since 1954. Retired CBS broadcaster Charles Kuralt was a part-owner of the station for several years. Above, Leo DuRocher (left) and John Somrock appear to be awarding fishing tackle during a broadcast. (Courtesy of Ely-Winton History Museum.)

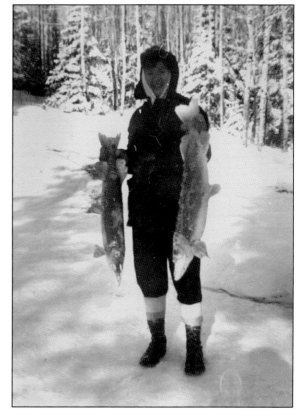

One of the advantages of fishing through the ice in winter over fishing on a warm summer day is the obvious ability to keep the catch cold until it is time to make fillets. It is not uncommon to find winter anglers with fish that are frozen stiff, such as the two pike held by this woman in the Ely area. (Courtesy of Ely-Winton History Museum.)

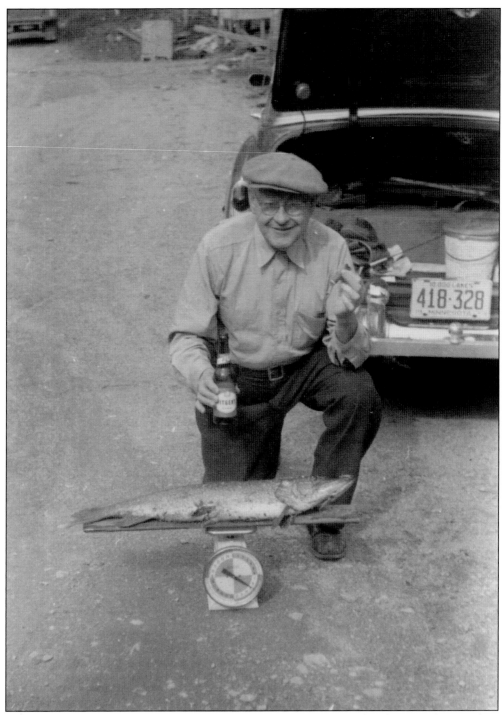

This northern pike weighed nine pounds, according to the scale. The photograph was taken in 1956 at Jasper Lake Resort (now known as Northwind Lodge). The man is holding a Fitger's beer, which has been produced by the well-known Fitger's Brewhouse, located in Duluth, since the 1800s.

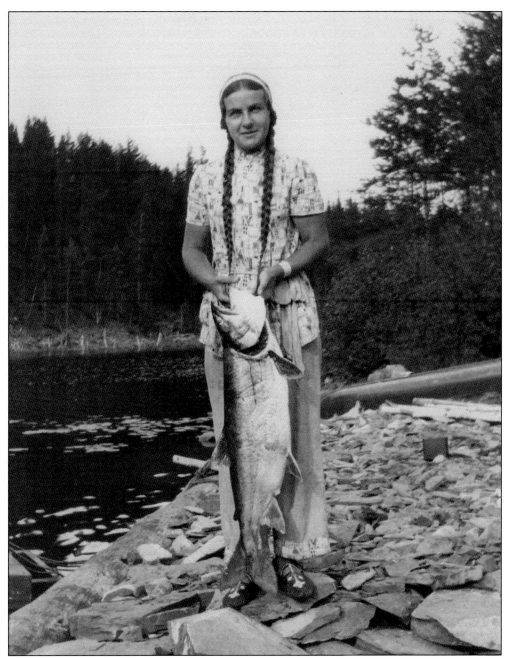

Dorothy Molter was the last permanent resident of the Boundary Waters Canoe Area Wilderness. She lived on Knife Lake for more than 56 years, where she operated the Isle of Pines Resort. Knife Lake is one of several cold, deep lakes in the northern part of the state that support a healthy population of lake trout. In this 1930s photograph, Molter is holding a lake trout that likely weighs over 20 pounds. (Courtesy of Dorothy Molter Museum.)

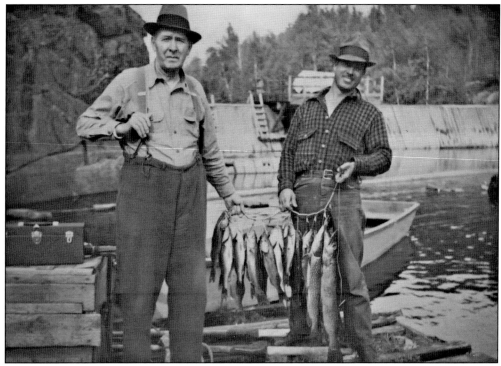

Jim Bolinger (left) and August Seliskar Sr. are pictured here after a good day of fishing for northern pike and walleye near the Gabbro Lake dam. Bolinger was stationed at the dam and adjusted the gate to control the water level, which powered turbines at the Fall Lake hydroelectric dam many miles downstream. Operation of the dam was discontinued in 1940. Seliskar owned and operated Pine Point Lodge on White Iron Lake. (Courtesy of Ely-Winton History Museum.)

ONE DAY VACATION SPECIAL

Follow the historic routes of early Voyageurs on an excursion to Bill Zup's Lac La Croix lodge. Excursion.. leaves.. Crane.. Lake Landing at 10 a.m. on Saturday and.. Sunday mornings, then.. a boat stop at Canadian Customs and then to the modern lodge at Lac La Croix for lunch.

After lunch a beautiful scenic cruise to Painted Rock and then back to the Crane Lake Landing at 5 p.m. Cost of round trip is only $10 with a minimum of four persons.

For $19.50 per person, round trip, you can fly-in to Bill Zup's from Ely. Luxurious facilities at the lodge, fantastic fishing action, complete outfitting for campers and canoists.

BILL ZUP'S FISHING CAMP

On Beautiful Lac La Croix

Phone 365-4018 for Details

Most advertisements for camps and resorts tout the area's fishing and hunting to draw visitors. This 1968 advertisement for Bill Zup's Fishing Camp offered a one-day boating excursion from Crane Lake in Minnesota into Lac La Croix in Canada for only $10 per person. The camp was owned by William "Bill" Zupancich until his death in 1989, and it is still owned and operated by the Zupancich family.

108

Lake Insula is within the Boundary Waters Canoe Area Wilderness. Despite the rocky terrain of the region, it features a few picturesque sand beaches. In this c. 1945 photograph, Cathryn Gabrielson stands on a Lake Insula beach and displays a nice northern pike she caught. (Courtesy of Minnesota Historical Society.)

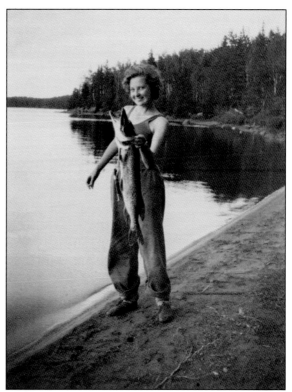

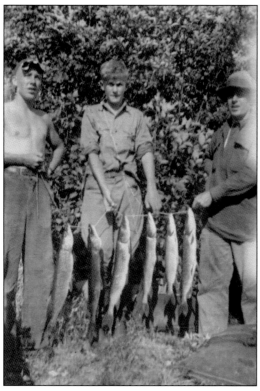

These Boy Scouts show off a nice stringer of northern pike in 1935. The fish were caught during a wilderness canoe trip out of the Charles L. Sommers Canoe Base on Moose Lake. (Courtesy of North Star Museum of Boy Scouting and Girl Scouting.)

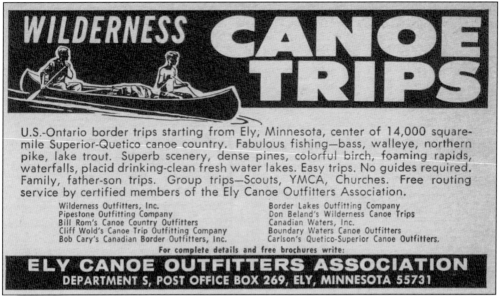

This 1968 advertisement for the Ely Canoe Outfitters Association promotes the fabulous fishing and superb scenery of the state's canoe country. Ely-area author Bob Cary was among the founders of the association. He made national headlines in 1980 by running for president on the fictitious Independent Fisherman's Party ticket.

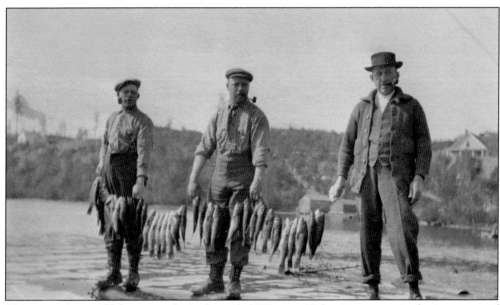

This nice stringer of fish was caught in the early 1900s near Coleraine, a town in the iron range of Minnesota on the north side of Trout Lake. This photograph was likely taken next to Trout Lake; however, despite the name of the lake, the fish appear to be bass. According to the Minnesota Department of Natural Resources, there are no trout in Trout Lake near Coleraine.

110

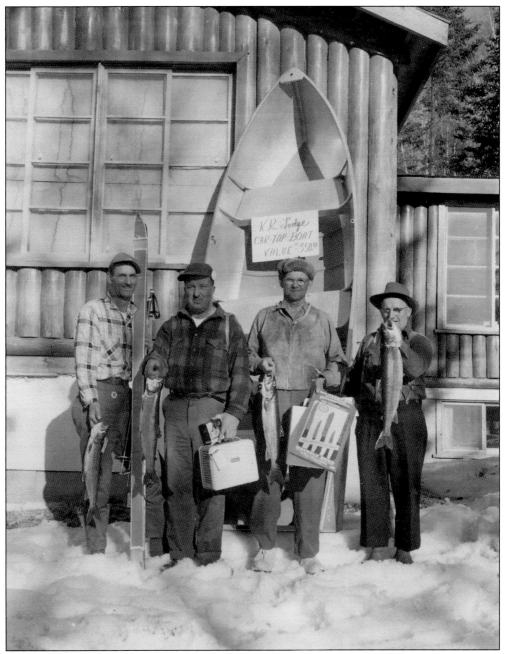

Hooking into a lake trout in winter is an exhilarating angling experience. Lake trout are known for their ability to peel line from a reel as they make mad runs and are difficult to land through a hole in the ice. The men in this photograph are holding the winning fish in the 1961 "Trout a Rama" held near Ely. (Courtesy of Ely-Winton History Museum.)

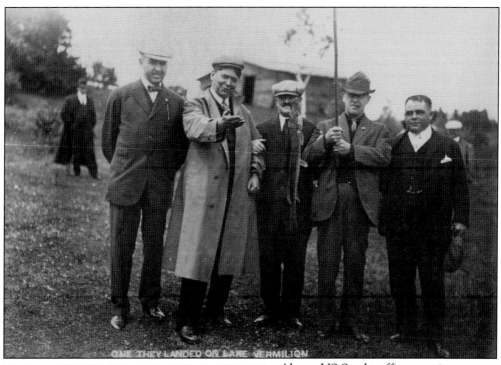

ONE THEY LANDED ON LAKE VERMILION

Above, US Steel traffic committee members pose with a less-than-impressive northern pike they caught on Lake Vermilion in 1912. (Courtesy of Minnesota Museum of Mining.)

This photograph shows a great catch of northern pike out of Handberg's Northwoods Lodge on Crane Lake. The lodge went out of business, but the building was preserved and moved to the Life of Riley Resort on Lake Vermilion.

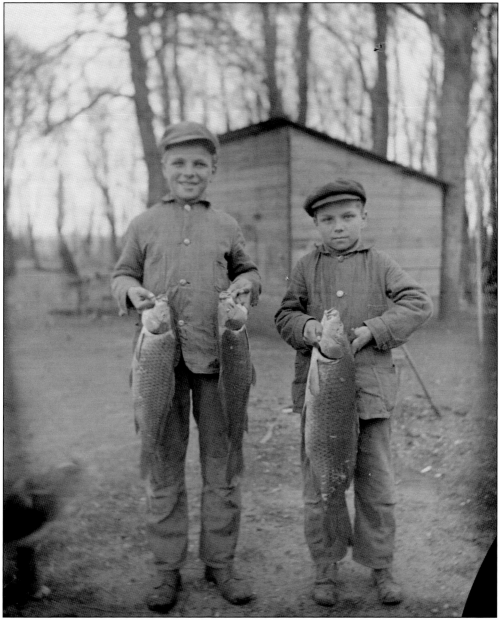

The young boys shown here around 1915 must have had fun hauling in large carp. The photograph was taken by Louis Enstrom, possibly in the Bovey area. Enstrom's brother Eric, a professional photographer, captured the famous picture titled *Grace*, which shows Charles Wilden praying before a meal in Bovey, Minnesota; the image was later sold as an oil painting. (Courtesy of Minnesota Historical Society.)

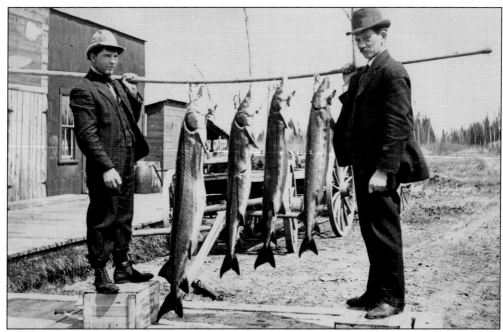

These lake sturgeon were caught around 1919 near Big Falls, a town along the Big Fork River, which is a tributary of the Rainy River (which remains a popular lake sturgeon destination). The area was first used by the Chippewa to net and spear sturgeon, especially during the spring spawning season. (Courtesy of Minnesota Historical Society.)

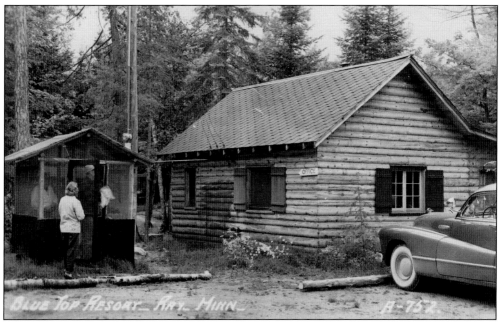

The small structure at left was most likely used for cleaning fish. The screened buildings served as gathering places to exchange stories and find out how other anglers did after a day's fishing. This 1939 image shows the Blue Top Resort, which was likely located on Kabetogama Lake.

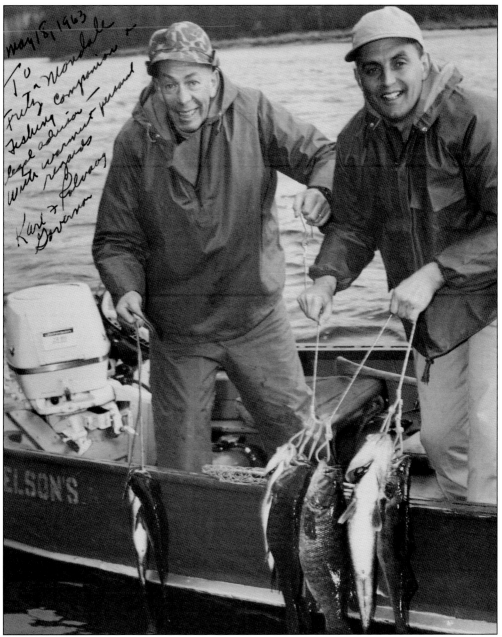

Minnesota's 31st governor, Karl Rolvaag (left), and attorney general Walter Mondale display their Crane Lake catch on opening day of the 1963 fishing season. In 1965, Governor Rolvaag signed a law designating the walleye as Minnesota's state fish. Mondale later served as a United States senator (from 1964 to 1976) and as the 42nd vice president of the United States under Pres. Jimmy Carter (from 1977 to 1981). (Courtesy of Minnesota Historical Society.)

With its relatively bone-free, white fillets, the walleye is considered excellent table fare and has long lured anglers to Minnesota. LeRoy Chiovitte caught the current state record walleye in May 1979 at the mouth of the Seagull River in Cook County. The record fish (far left) weighed 17 pounds and 8 ounces and was almost 36 inches long. It was one of several large walleyes Chiovitte caught that weekend. (Courtesy of Minnesota Department of Natural Resources.)

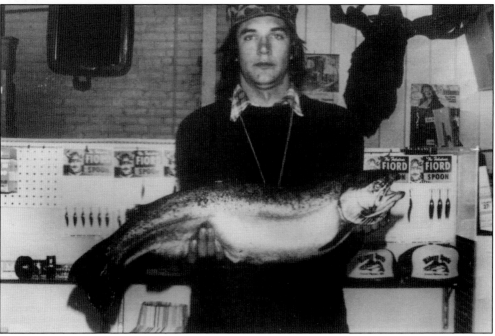

Scott Thorpe caught this 16-pound, 6-ounce rainbow trout in the Devil Track River in April 1980. At the time, the state record fish (caught in 1974) was one pound larger. However, 23 years after Thorpe caught this fish, the angler who caught the larger 1974 fish confessed that he had lied about it. Thus the old record was expunged and Thorpe's fish was recognized as holding the state record. In the 1980s, the Minnesota Department of Natural Resources tightened the application process for record fish and required the use of state-certified scales in front of two witnesses. (Courtesy of Minnesota Department of Natural Resources.)

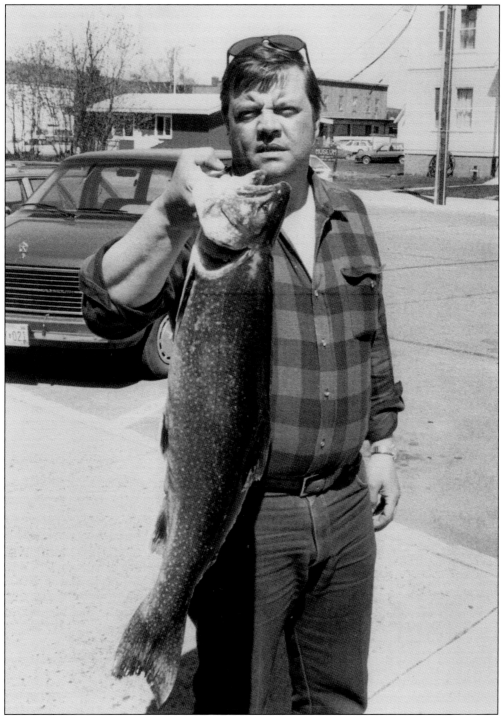

A splake is a cross between a brook trout and a lake trout. Splake are stocked in several deep, cold lakes. In May 1986, David Leitten caught this 10-pound, 4-ounce splake in Birch Lake in Cook County. The current state record for a splake is 13 pounds, 5 ounces. (Courtesy of Minnesota Department of Natural Resources.)

This one-pound, six-ounce pink salmon was caught by Donald Woods in Lake Superior in 1979. For a time, it was the state record. The pink salmon is not native to Lake Superior, but it was unintentionally released into Thunder Bay in 1956 and has since spread throughout the Great Lakes. (Courtesy of Minnesota Department of Natural Resources.)

Steven Griep caught this 12-pound, 8-ounce Atlantic salmon in Lake Superior one early morning in 1983. It was a state record at the time and is only five ounces shy of the current state record fish (which was caught in 1991). Atlantic salmon were stocked in Minnesota's portion of Lake Superior in the 1980s and early 1990s. (Courtesy of Minnesota Department of Natural Resources.)

Carl Lovgren caught this 91-pound sturgeon in Grindstone Lake in 1969. An article in the *St. Paul Dispatch* stated that the ensuing battle lasted for four hours, with Lovgren eventually landing the huge fish on a sandy shore. The fish was 66 inches long and had to be weighed on a scale usually used for beef. Lovgren owned a cabin on Grindstone Lake; there, in 1961, he also caught a 16-pound, 8-ounce brown trout that held the state record for a time. (Courtesy of Minnesota Department of Natural Resources.)

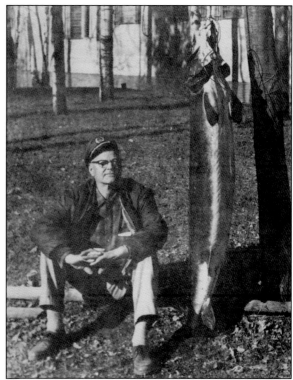

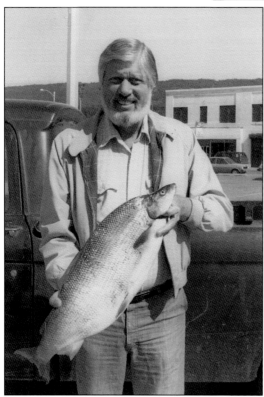

The average whitefish weighs about four pounds. Roger Norgren caught this 10-pound, 6-ounce specimen at the mouth of the Devil Track River in Lake Superior in 1983. It was the state record for a time. The whitefish was a major part of Minnesota's commercial fishing in Lake Superior until populations declined in the 1950s due to pollution, overfishing, and the arrival of the sea lamprey, a parasite that latches onto fish. (Courtesy of Minnesota Department of Natural Resources.)

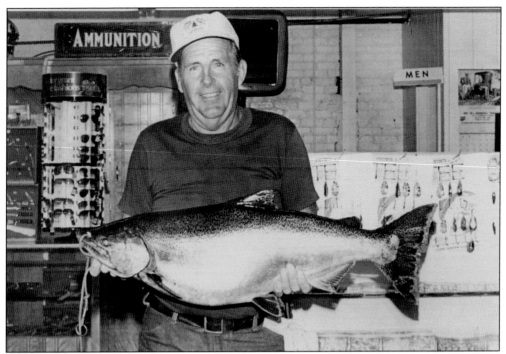

H.J. Niedorf caught this 21-pound, 4-ounce chinook salmon just outside the entrance to the Grand Marais Harbor on July 17, 1980. This fish held the state record for about a year. Several unsuccessful attempts to introduce the chinook into inland Minnesota waters were made as early as 1876. In 1967, chinook fingerlings were successfully stocked in the Huron River, a tributary into Lake Superior. (Courtesy of Minnesota Department of Natural Resources.)

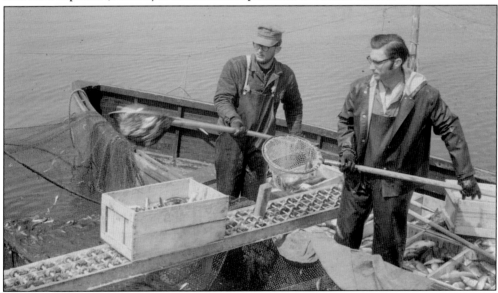

Rainbow smelt are an invasive species first discovered in Lake Superior in 1946. The population grew rapidly, peaking in the late 1960s. In this 1968 image, commercial fishermen load smelt from their nets into boxes. (Courtesy of Northeast Minnesota Historical Center, University of Minnesota Duluth; photograph by Elizabeth Jo Goodsell.)

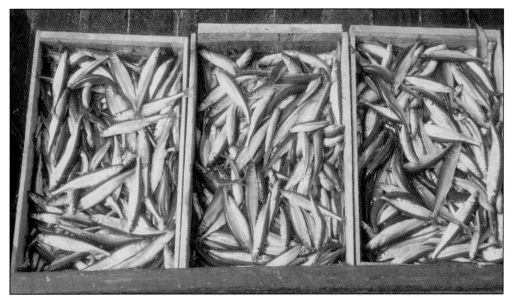

During the smelt peak, it was not difficult to catch smelt by the hundreds. While these boxes were filled by commercial fishermen, noncommercial anglers flocked to Lake Superior streams and beaches with nets every spring to participate in "smelting." (Courtesy of Northeast Minnesota Historical Center, University of Minnesota Duluth; photograph by Elizabeth Jo Goodsell.)

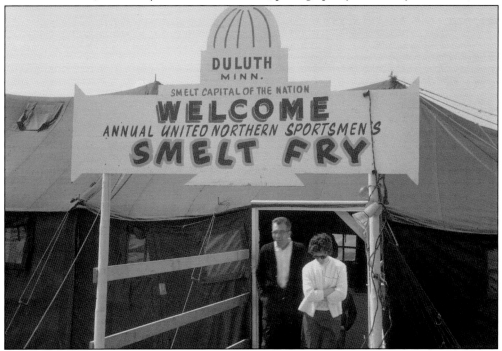

Just about everyone who has lived in the Duluth area has heard of or been to a smelt fry. During the smelt heyday in the 1960s, Duluth was known as the "smelt capital of the nation." Since that time, smelt numbers have declined significantly for a number of reasons, including predation by an increasing lake trout population. (Courtesy of Northeast Minnesota Historical Center, University of Minnesota Duluth; photograph by Elizabeth Jo Goodsell.)

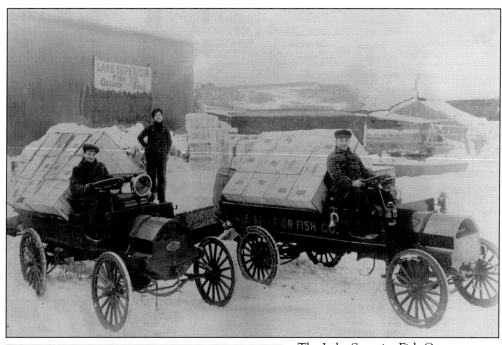

The Lake Superior Fish Company was founded in 1892 and provided fresh, frozen, and salted fish to Duluth and other points along the north shore of Lake Superior. The 1920s photograph above shows fish being transported in vehicles built by the Chase Motor Truck Company. (Courtesy of Northeast Minnesota Historical Center, University of Minnesota Duluth; photograph by H. McKenzie.)

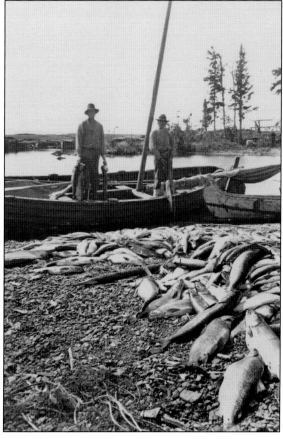

These two men appear to have had a good day fishing on Lake Superior, likely using nets, in the late 1800s. (Courtesy of Northeast Minnesota Historical Center, University of Minnesota Duluth; photograph by Paul B. Gaylord.)

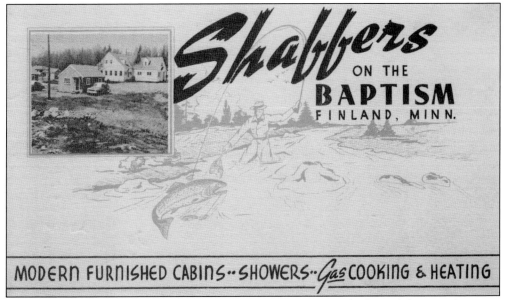

Shaffers

ON THE
BAPTISM
FINLAND, MINN.

MODERN FURNISHED CABINS·· SHOWERS·· *Gas* COOKING & HEATING

The Baptism River has long been known for its excellent trout and salmon fishing, as shown on this 1948 postcard. The river is where the state record Atlantic salmon was caught. Approximately 1.5 miles inland from Lake Superior, the river drops 60 feet, creating the largest waterfall entirely within the state of Minnesota.

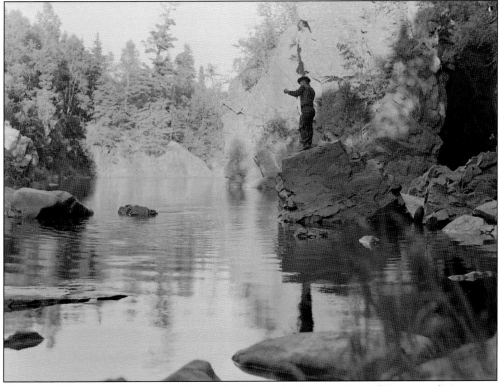

This 1937 photograph shows an angler perched along the Baptism River. (Courtesy of Minnesota Historical Society.)

These fish—probably lake trout from Lake Superior—had already been partially processed before being photographed around 1900. Even so, this was an impressive catch. The three fish along the top were likely over 10 pounds each. (Courtesy of William R. Opie Photographic Collection, Minnesota Discovery Center.)

In 1919, these Elba mine employees enjoyed a Fourth of July celebration near Biwabik. These attendees paused for a moment to have their stringer of walleye photographed. (Courtesy of Leo Boyanowski Photographic Collection, Minnesota Discovery Center.)

This book is dedicated to my dad, Theodore E. Uehling, who taught me how to tie a knot and thread a cisco and gave me a passion for fishing.

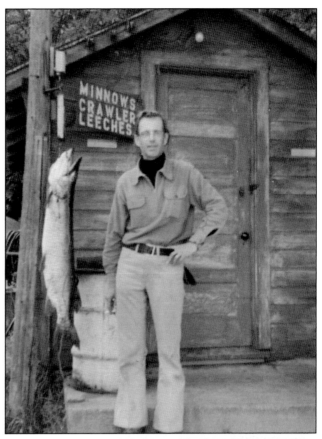

It is also dedicated to my mom, Anne Uehling, who taught me how to appreciate and enjoy the Minnesota wilderness.

STATE RECORD FISH

This is a complete list of Minnesota's state record fish and where they were caught. Weights given are in pounds and ounces. For example, "55-5" represents a fish weighing 55 pounds and 5 ounces. (Courtesy of Minnesota Department of Natural Resources.)

Species	Weight (lbs. - oz.)	Length/girth (inches)	Where caught	Date
Bass, Largemouth	8-15	23.5 / 18	Auburn Lake	10/05/2005
Bass, Rock (tie)	2-0	13.5 / 12.5	Osakis Lake	05/10/1998
	2-0	12.6 / 12.4	Lake Winnibigoshish	08/30/2004
Bass, Smallmouth	8-0	n/a	West Battle Lake	1948
Bass, White	4-2.4	18.5 / 15.1	Mississippi River Pool 5	05/04/2004
Bluegill	2-13	n/a	Alice Lake	1948
Bowfin	12-9	31.5 / 18	Mississippi River	09/14/2012
Buffalo, Bigmouth	41-11	38.5 / 29.5	Mississippi River	05/07/1991
Buffalo, Black	20-0	34.2 / 20	Minnesota River	06/26/1997
Buffalo, Smallmouth	20-0	32 / 23.75	Big Sandy	09/20/2003
Bullhead, Black	3-13.12	17.17 / 14.96	Reno Lake	06/08/1997
Bullhead, Brown	7-1	24.4 / n/a	Shallow Lake	05/21/1974
Bullhead, Yellow	3-10.5	17 7/8 / 11.75	Osakis Lake	08/05/2002
Burbot	19-8	36.5 / 24	Lake of the Woods	02/24/2012
Carp	55-5	42 / 31	Clearwater Lake	07/10/1952
Carpsucker, River	4-6	21.7 / 16	Minnesota River	11/19/2012
Catfish, Channel	38-0	44 / n/a	Mississippi River	1975
Catfish, Flathead	70-0	n/a	St. Croix River	1970
Crappie, Black	5-0	21 / n/a	Vermillion River	1940
Crappie, White	3-15	18 / 16	Lake Constance	07/28/2002
Drum, Freshwater (Sheepshead)	35-3.2	36 / 31	Mississippi River	10/05/1999
Eel, American	6-9	36 / 14	St. Croix River	08/08/1997
Gar, Longnose	16-12	53 / 16.5	St. Croix River	05/04/1982
Gar, Shortnose	4-9.6	34.6 / 10	Mississippi River	07/22/1984
Goldeye	2-13.1	20.1 / 11.5	Root River	06/10/2001
Hogsucker, Northern	1-15	14.25 / 7.125	Sunrise River	08/16/1982
Mooneye	1-15	16.5 / 9.75	Minnesota River	06/18/1980
Muskellunge	54-0	56 / 27.8	Lake Winnibigoshish	1957
Muskellunge, Tiger	34-12	51 / 22.5	Lake Elmo	07/07/1999

Species	Weight (lbs. - oz.)	Length/girth (inches)	Where caught	Date
Perch, Yellow	3-4	n/a	Lake Plantaganette	1945
Pike, Northern	45-12	n/a	Basswood Lake	05/16/1929
Pumpkinseed	1-5.6	10.1 / 12.125	Leech Lake	06/06/1999
Quillback	7-4.5	22 58 / 18	Upper Red Lake	08/09/2010
Redhorse, Golden	3-15.5	20.125 / 12.375	Root River	04/30/2007
Redhorse, Greater	12-11.5	28.5 / 18.5	Sauk River	05/20/2005
Redhorse, River	12-10	28.38 / 20	Kettle River	05/20/2005
Redhorse, Shorthead	7-15	27 / 15	Rum River	08/05/1983
Redhorse, Silver	9-15	26.6 / 16.875	Big Fork River	04/16/2004
Salmon, Atlantic	12-13	35.5 / 16.5	Baptism River	10/12/1991
Salmon, Chinook (King) (tie)	33-4	44.75 / 25.75	Poplar River	09/23/1989
	33-4	42.25 / 26.13	Lake Superior	10/12/1989
Salmon, Coho	10-6.5	27.3 / n/a	Lake Superior	11/07/1970
Salmon, Kokanee	2-15	20 / 11.5	Caribou Lake	08/06/1971
Salmon, Pink	4-8	23.5 / 13.2	Cascade River	09/09/1989
Sauger	6-2.75	23.875 / 15	Mississippi River	05/23/1988
Splake	13-5.44	33.5 / 19	Larson Lake	02/11/2001
Sturgeon, Lake	94-4	70 / 26.5	Kettle River	09/05/1994
Sturgeon, Shovelnose	6-7	33 / 13.9	Mississippi River	02/19/2012
Sucker, Blue	14-3	30.4 / 20.2	Mississippi River	02/28/1987
Sucker, Longnose	3-10.6	21 / 10.25	Brule River	05/19/2005
Sucker, White	9-1	24.25 / 16.25	Big Fish Lake	05/01/1983
Sunfish, Green	1-4.8	10.25 / 10.625	North Arbor Lake	06/14/2005
Sunfish, Hybrid	1-12	11.5 / 12	Zumbro River	07/09/1994
Trout, Brook	6-5.6	24 / 14.5	Pigeon River	09/02/2000
Trout, Brown	16-12	31.4 / 20.6	Lake Superior	06/23/1989
Trout, Lake	43-8	n/a	Lake Superior	05/30/1955
Trout, Rainbow (Steelhead)	16-6	33 / 19.5	Devil Track River	04/27/1980
Trout, Tiger	2-9.12	20 / 9.625	Mill Creek	08/07/1999
Tullibee (Cisco)	5-11.8	20.45 / 16.40	Little Long Lake	04/16/2002
Walleye	17-8	35.8 / 21.3	Seagull River	05/13/1979
Walleye-Sauger Hybrid	9-13.4	27 / 17.75	Mississippi River	03/20/1999
Warmouth	0-9	8.75 / 8	Pool 6 Bartlet Lake	12/23/2011
Whitefish, Lake	12-4.5	28.5 / 20	Leech Lake	03/21/1999
Whitefish, Menominee (Round)	2-7.5	21 / 9.1	Lake Superior	04/27/1987

Discover Thousands of Local History Books Featuring Millions of Vintage Images

Arcadia Publishing, the leading local history publisher in the United States, is committed to making history accessible and meaningful through publishing books that celebrate and preserve the heritage of America's people and places.

Find more books like this at
www.arcadiapublishing.com

Search for your hometown history, your old stomping grounds, and even your favorite sports team.

Consistent with our mission to preserve history on a local level, this book was printed in South Carolina on American-made paper and manufactured entirely in the United States. Products carrying the accredited Forest Stewardship Council (FSC) label are printed on 100 percent FSC-certified paper.

MADE IN THE